THE
SPORTS
PHOTOGRAPHER
OF THE
YEAR BOOK

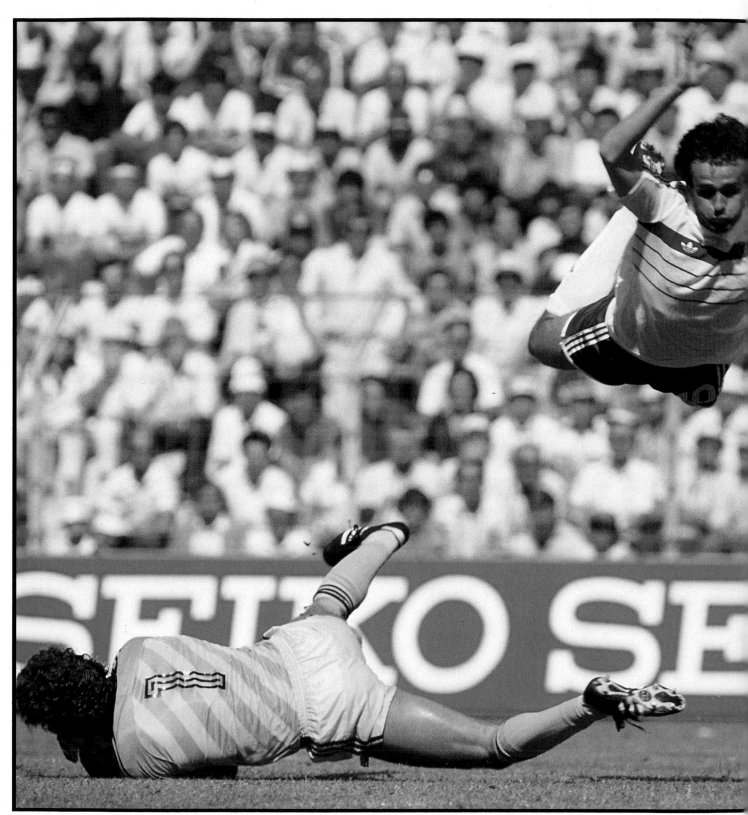

Michel Platini challenges the Belgian goalkeeper during the European soccer finals in 1984 which proved a double triumph for the French: thcir team won the title and Platini was elected European Footballer of the Year (*Trevor Jones/All-Sport*)

THE
SPORTS
PHOTOGRAPHER
OF THE
YEAR BOOK
The Last 10 Years

The Kingswood Press

Edited and Designed by Graeme Murdoch
Text by Doug Gardner

Photographs © 1985 as credited

Text copyright © 1985 Sports Council

Published by The Kingswood Press, Kingswood, Tadworth, Surrey
An imprint of William Heinemann Ltd.

Reproduced by East Anglian Engraving Co. Ltd.

Printed and Bound in Great Britain by William Clowes Ltd., Beccles and London

0 434 98074-9

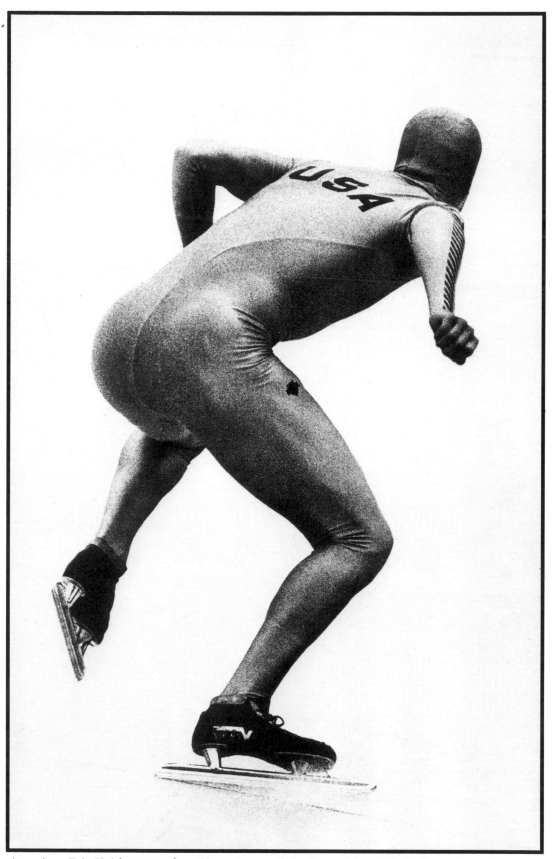

American Eric Heiden won five Olympic speed-skating gold medals in the Winter Games at Lake Placid (*Chris Smith/Sunday Times*)

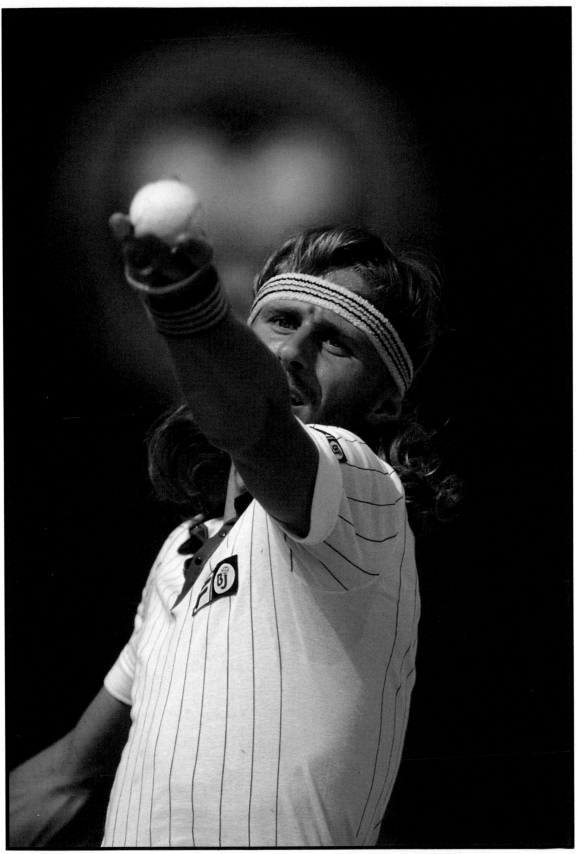

Bjorn Borg, had a tight hold on the Wimbledon singles title *(Steve Powell/All-Sport)*

FOREWORD

BY JOHN SMITH, CBE, JP, DL,
CHAIRMAN OF THE SPORTS COUNCIL

All of us involved in the promotion of sport owe a special debt of gratitude to that talented and tenacious breed who fill the back pages of our newspapers with eye-catching images of the best sporting action from around the world.

Sports photographers capture and convey the excitement of sporting endeavour and through their work can help cajole more people out of their armchairs and into track-suits.

Increasing participation in sport is what the Sports Council is all about. We have been delighted, therefore, in partnership with the Royal Photographic Society, to build a close association with sports photographers through this competition, and increase the awareness of the special qualities – skill, patience and versatility – that their art requires.

Taken at face value, sports photographers enjoy a glamorous existence. The reality can be very different. Pictures of the quality shown in this book are often the product of demanding assignments, requiring dedication and endurance, as well as a keen eye.

It has not been possible to include all the outstanding entries of the last decade, but this book does reflect the consistently high standard of British sports photographers, and the Sports Council is delighted to be associated with it.

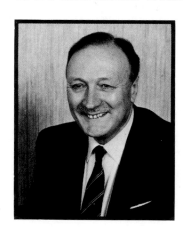

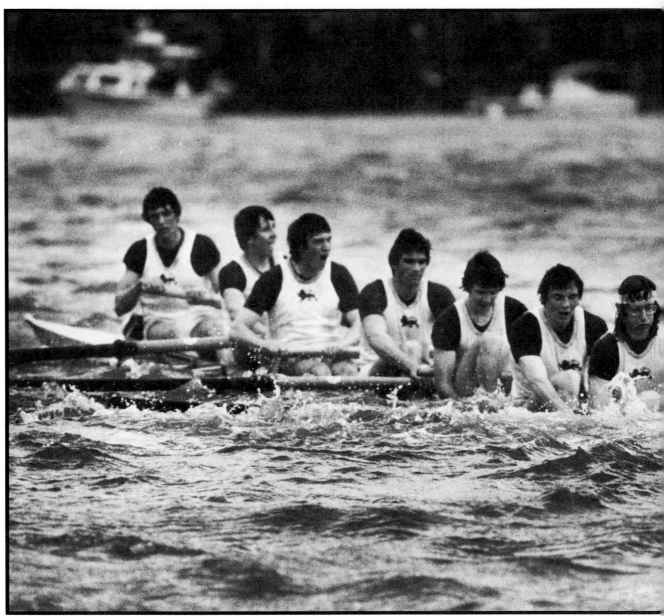

Going down . . . the 1978 Boat Race saw Cambridge provide the sixth sinking in their 124th encounter with Oxfo

(Eamonn McCabe/The Observer)

INTRODUCTION

BY MIKE LANGLEY (*SUNDAY PEOPLE*)
SPORTS JOURNALIST OF THE YEAR

The front-line troops of sporting journalism are known among themselves as smudgers and blunts, short for blunt-knibs, and they affect a mocking contempt for each other's craft. Compilers of the Oxford English Dictionary may not know this, but the collective nouns of these rival trades are a blur of smudgers and a scribble of blunts.

Scribble, I hardly need to say, is grossly defamatory of the writers, highly-educated, cultivated and sensitive people who would spend their days outdoing Shakespeare if only a cruel fate had not set them down in football grounds, dog tracks and pubs.

Blur, though, cannot be bettered in summarising photographers gathered again at the wrong end. Ask yourself why no pictures exist of all Joe Payne's 10 goals for Luton Town in 1936? Was it a sudden April shower dampening the flash tray, someone jogging the smudger's elbow or Payne inconsiderately shooting during re-loading?

Smudgers' excuses have not changed in half a century, neither has their knack for always being first to the free drinks before commandeering the last taxi.

They also scrounge reporters' cigarettes, interrupt interviews and, when reproached, fall back on illogical arguments about their hard life lying by the side-nets in snow, rain and fog while the cossetted blunts wolf tea and sandwiches in the board-room before stringing together a few halting and usually inaccurate sentences.

Smudgers at work inhabit smoky dens crammed with duty-frees and lurid paperbacks – and there, I suspect, they dream of one day shedding their burden of oilskins, zoom-lens, Nikons and tripods to dazzle Fleet Street with their mastery of language. No reporter suffers from the parallel delusion. We know we could never take better pictures than the professionals – and this book is the proof.

Here are 120 photographs showing that the smudger, far from being useless, is sometimes quite brilliant. Mind you, it's taken 10 years to assemble the evidence!

1975

A glorious summer was overshadowed by the fag-end of a winter of severe discontent with the behaviour of soccer fans. The International Football Federation officially dubbed crowd violence 'The English Disease' after a riot at a European cup final for the third time in four years. Wembley had to fence in its pitch following an invasion after the Cup Final and thousands of Scots were forced to walk their way to the annual clash with England when London rail staff refused to operate trains to the venue. The move seemed to enrage the English more than the Scots and train-wrecking became such a national pastime at the start of the following season that British Rail withdrew its 'soccer specials' altogether.

Even cricket suffered: a midnight desecration of the Headingley wicket by supporters of a convicted criminal brought a Test against Australia to a premature end, but fortunately the resulting publicity did not bring a rush of imitations, unlike the appearance of sport's first streaker in the middle of the Lord's Test. Before the year was out three other men were baring all for bets in Australia – perhaps hoping to distract West Indies from repeating their victory in cricket's first World Cup in England.

But there were brighter headlines for the British: David Wilkie won our first swimming world championships gold medal and Virginia Wade led the first team to win the Wightman Cup in the USA for 30 years, while John H Stracey brought back the world welterweight boxing crown for the first time since 1919 after stopping the holder, Jose Napoles, in front of his home crowd in Mexico City. But the best official fight of the year was world heavyweight champion Muhammad Ali's win over 'Smokin' Joe' Frazier in their third meeting, which more than justified its title: 'The Thrilla in Manila'.

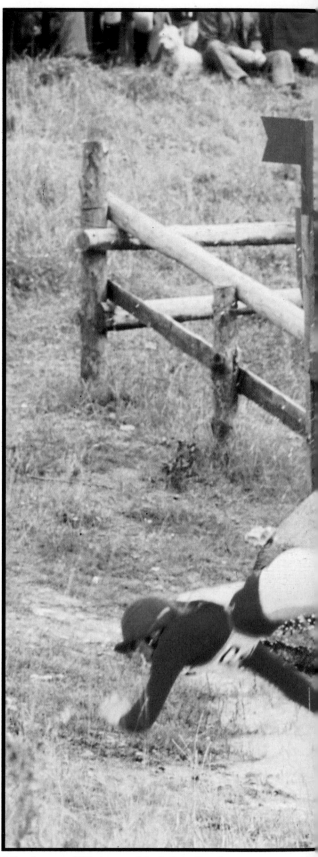

Miss Joanna Winter and Stainless Steel part company

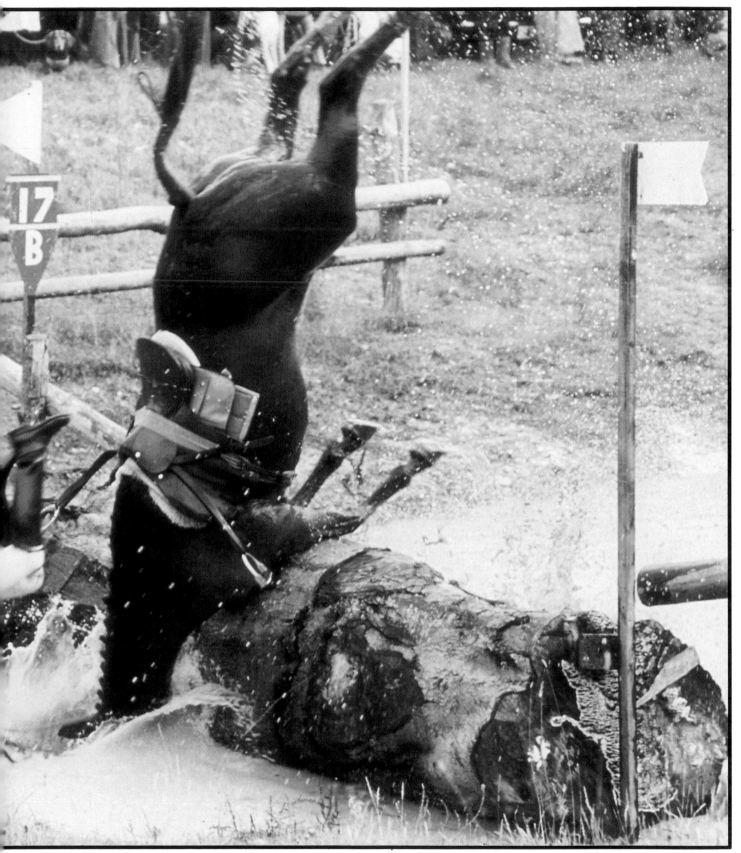

ng the Badminton Horse Trials (*Tony Duffy/All-Sport*)

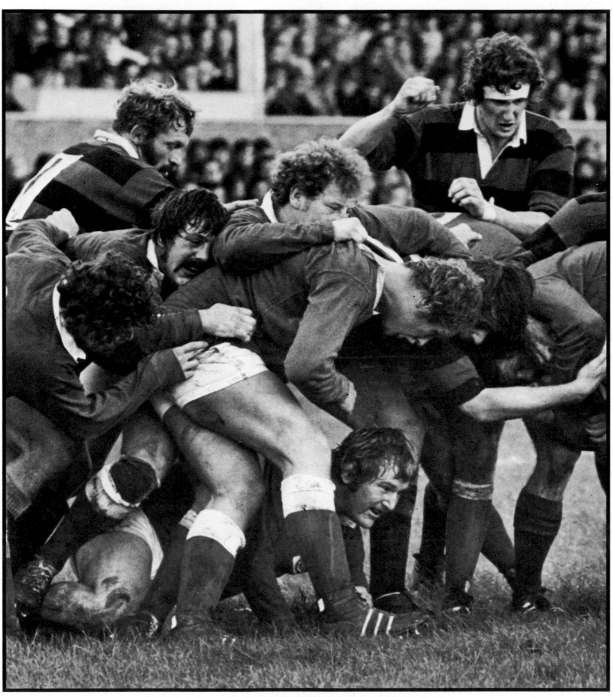

'But where's the ball'. . .? Derek Quinnell (Llanelli, Wales and the British Lions) in action untypical of the No. 8 forward against Moseley (*Ken Kelly*)

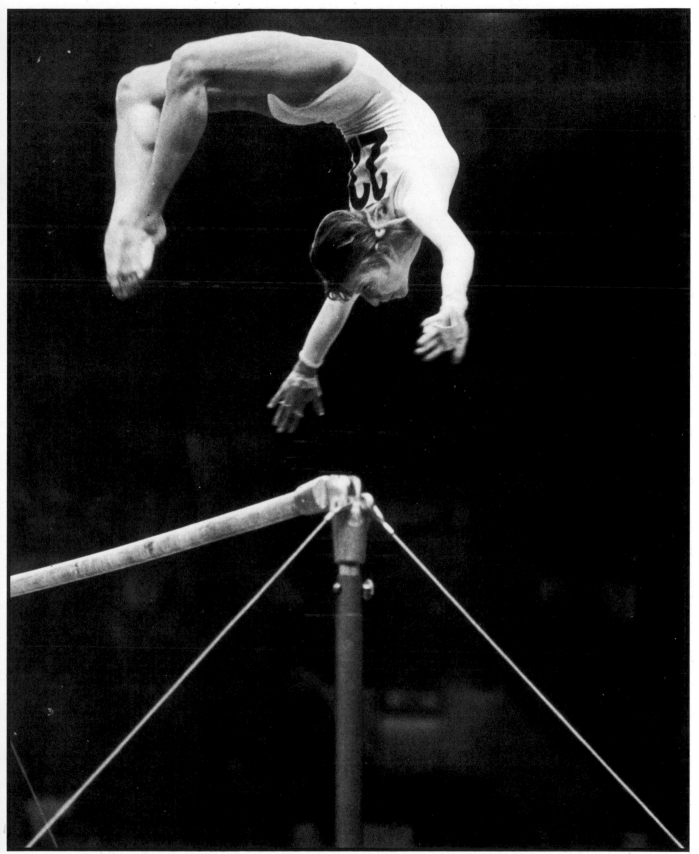

Olga Korbut, the elfin-like Soviet darling of the 1972 Olympics, was still performing gracefully at 20 (*Stewart Fraser*)

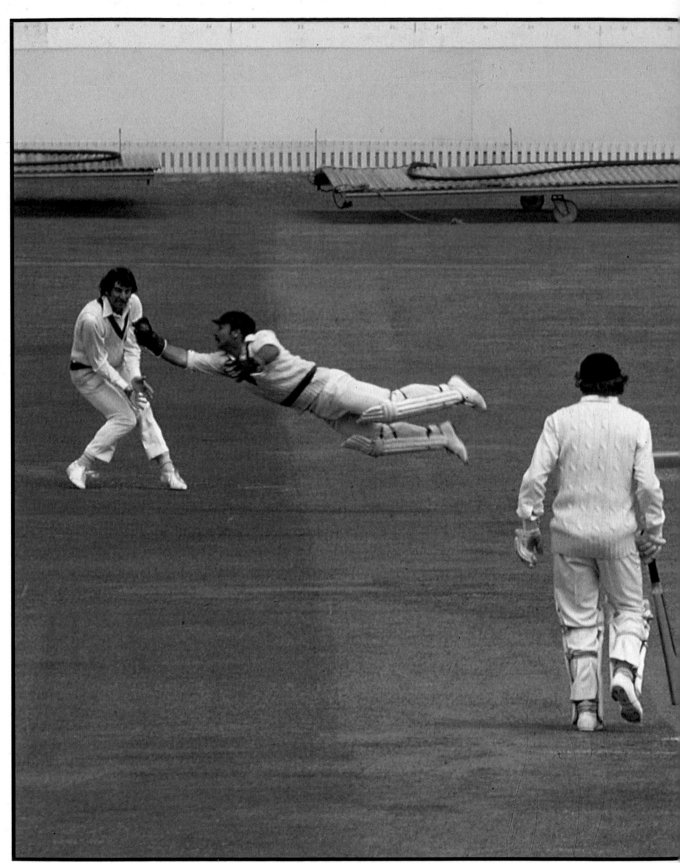

Few chances escaped the gloves of Rodney Marsh, whose agile wicket-keeping and staunch batting helped Austral

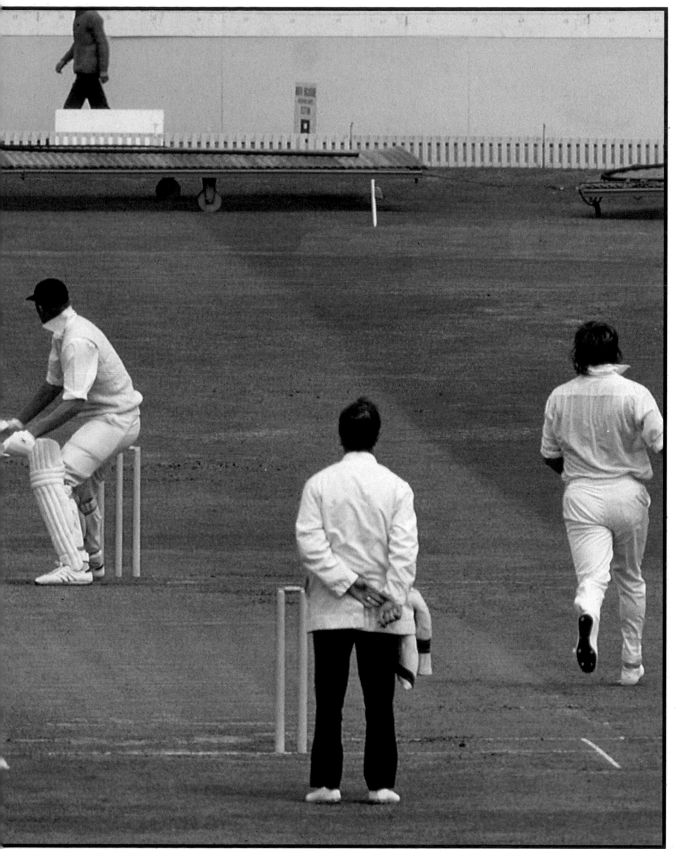

at England both at home and away in Ashes battles and in the semi-finals of cricket's first World Cup (*Patrick Eagar*)

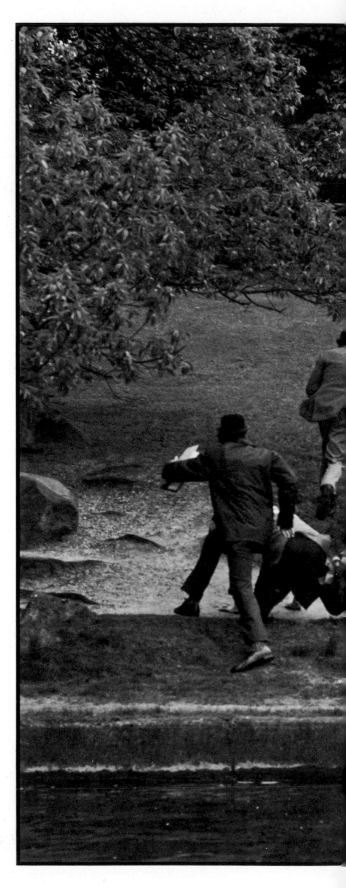

A Phaeton cart owned by the Queen turns over during the driving competition at the Royal Windsor Horse Show (*Mike Roberts*)

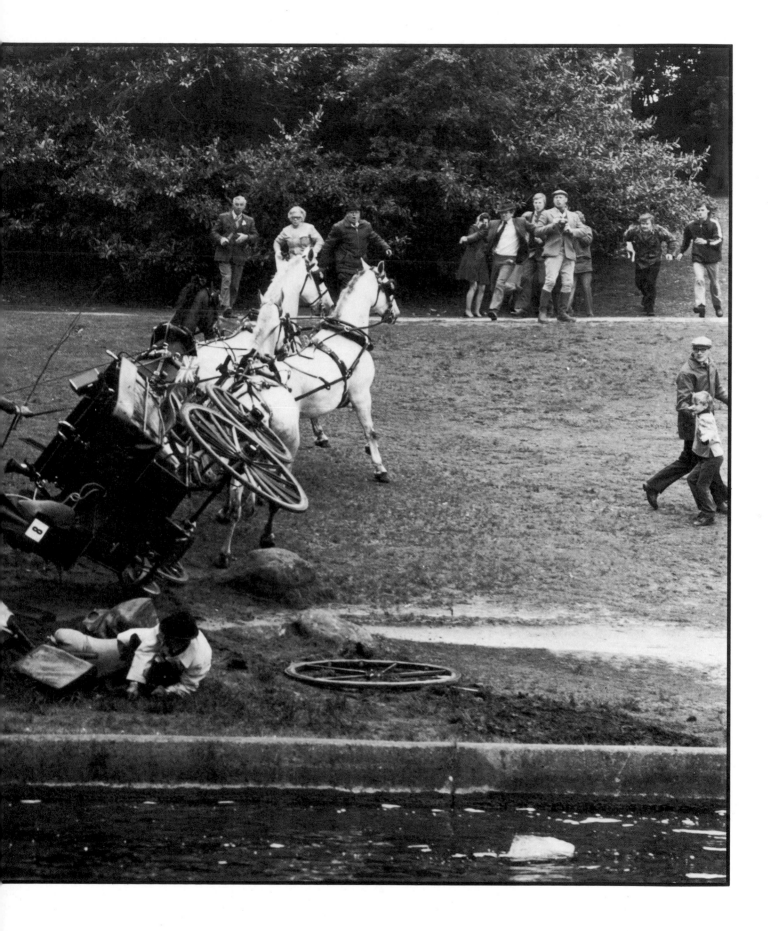

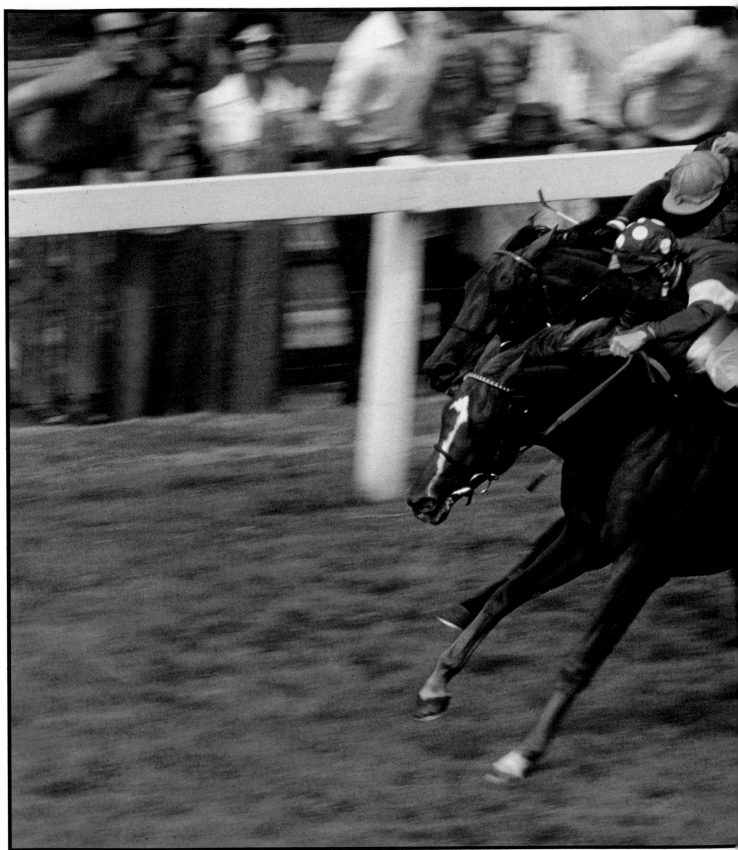

Pat Eddery gets top colt Grundy up to win a classic battle against Bustino in the King George VI and Queen Elizabeth Sta

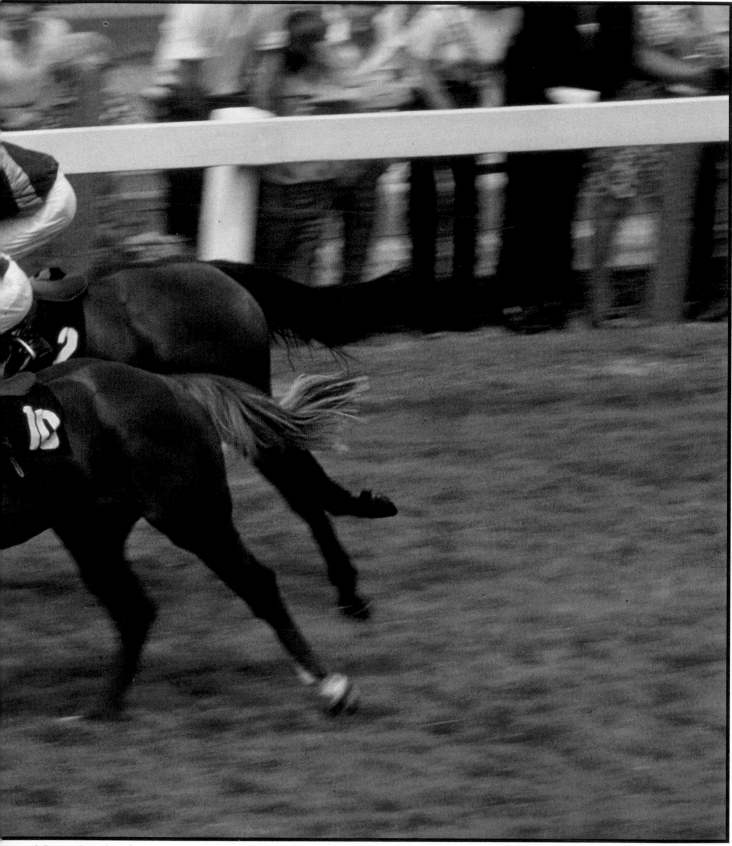

Ascot (*Gerry Cranham*)

1976

The aftermath of the massacre in Munich proved to be among the least of the Olympic problems which faced the jovial Irishman, Lord Killanin in his first term as president of the IOC and probably ultimately brought on the heart-attack which later struck him, thankfully not fatally. Innsbruck rescued the Winter Games, rejected by the citizens of Denver, Colorado, the first choice, and provided the stage for outstanding skiing by home hero Franz Klammer and West Germany's Rosi Mittermaier, the first British men's figure-skating gold medal for John Curry and a unique double for American Sheila Young, who added the 500 metres speed-skating champ-ionship to her world cycling title.

Canadians, particular-ly those in Quebec, may still be paying for not following Denver's lead, since Montreal ended up with the most expensive Summer Games in history. Grandiose building plans which never were completed; a vast political row over the Chinese; a mass boycott by the African nations; competitors disqualified for using drugs and one sent home for cheating at fencing and the excessive and often aggressive vigilance of more security people, many of them armed, than there were com-petitors, officials or press, turned the whole event into something not far distant from a shambles. About the only thing perfect was the first-ever maximum gymnastic points scored by the Rumanian Nadia Comaneci.

Young women tennis fans went wild when Bjorn Borg won his first Wimbledon while their elders again pocketed housekeeping profit when their favourite, Lester Piggott won his seventh Derby.

Nicki Lauda made the comeback of the century to nearly snatch the world driving championship from James Hunt only 10 weeks after receiving the Last Rites following a crash, and Johnny Miller won the Open golf with the lowest winning round, 66, in the cham-pionship's history, which beat by 55 the highest-ever round scored a few days earlier by a 46-year-old crane-driver, Maurice Flitcroft, who conned the R & A into letting him play 18 holes for the first time in his life.

This catch was one of the few highlights of the season for Tony Greig. It came in a Test series in which the West Indies fast bowlers Holding, Roberts, Holder and Daniel destroyed England – on one occasion putting them out for 71 – and left Greig, the first South African to skipper the side, with the longest losing record (nine matches, all at home, in 17 months) of any England captain (*Clive Limpkin/Daily Mail*)

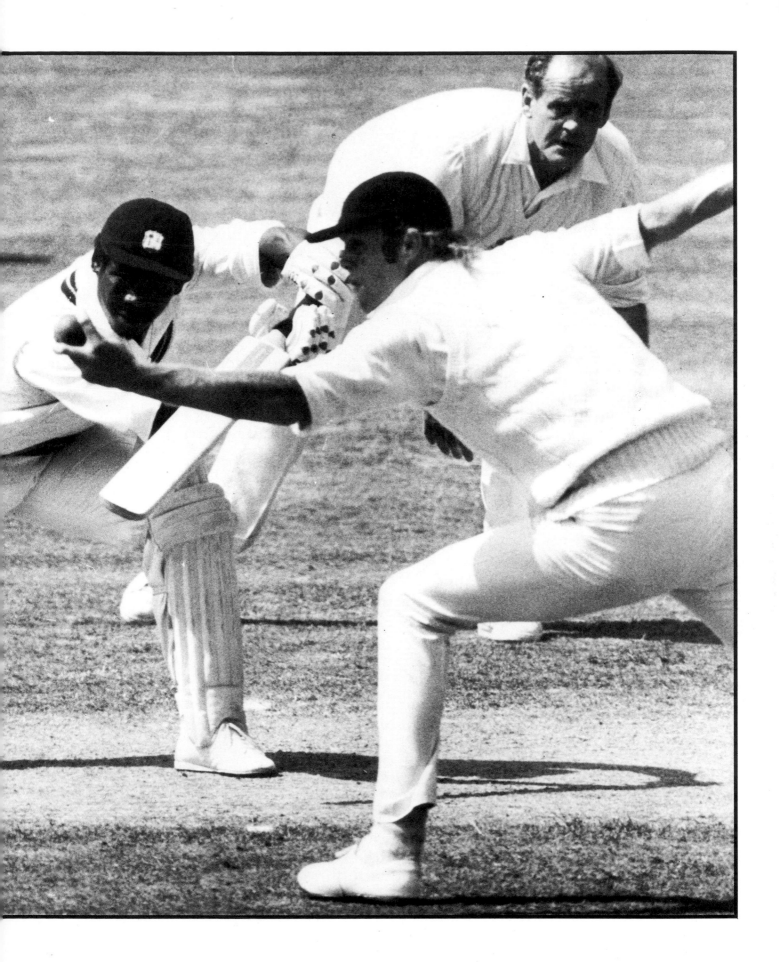

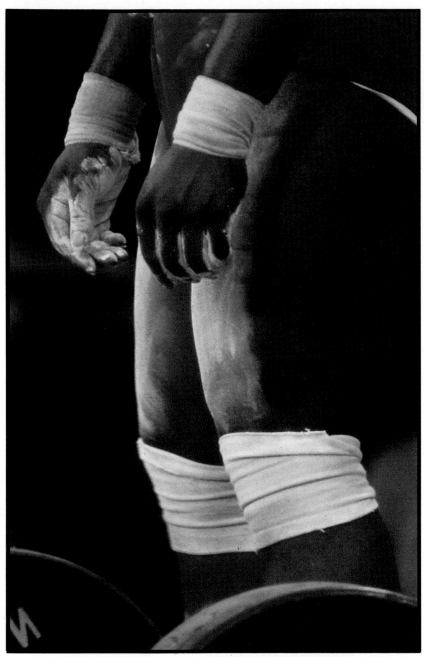

Waiting to lift at the Montreal Olympics where drug-testing innovations brought the disqualification of eight weight-lifters, including 2 gold medallists *(Chris Smith/The Observer Magazine)*

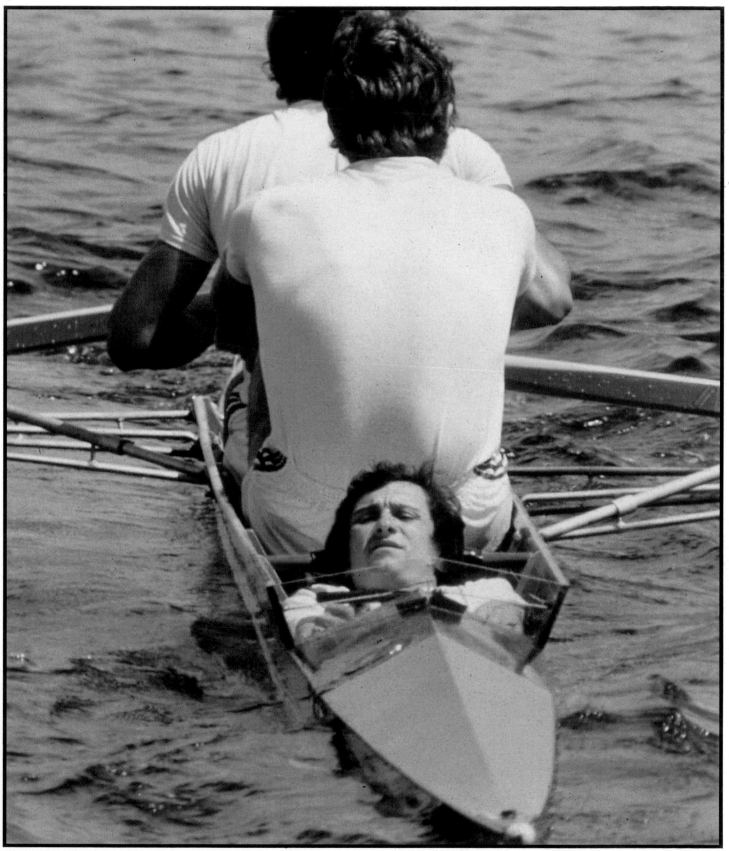
Coxes appeared (just) in the bows of boats for the first time in Olympic rowing *(Chris Smith/The Observer Magazine)*

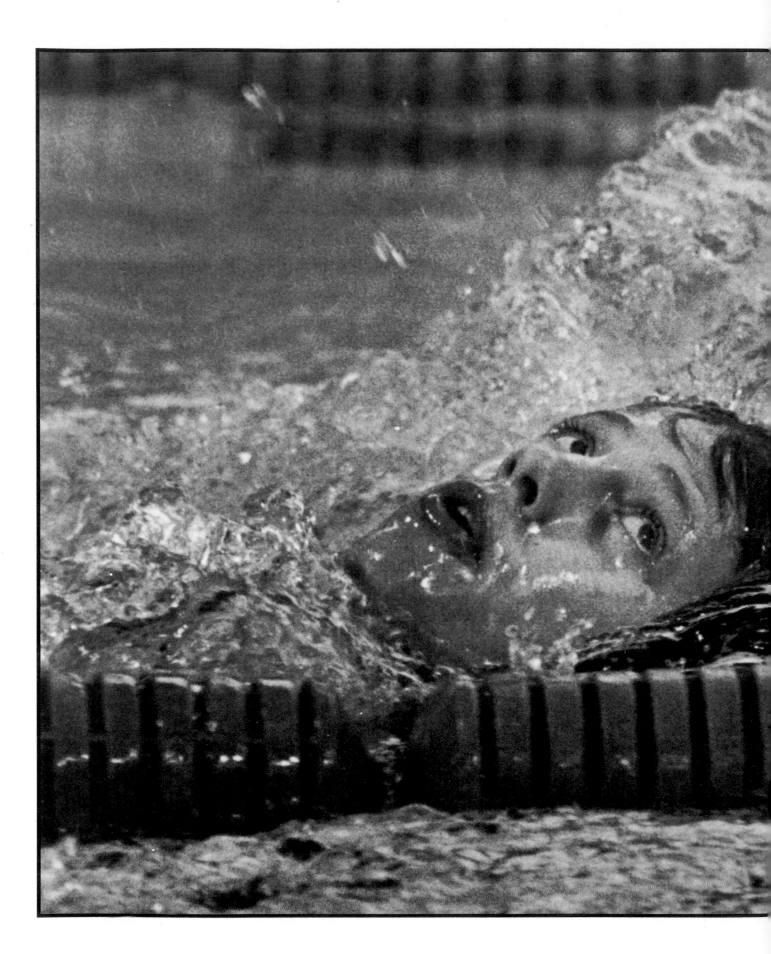

Thirteen year old Sharron Davies became one of the youngest ever selected for Olympic swimming, but glory went to David Wilkie, winning Britain's first gold in men's events for 68 years *(John Varley/Daily Mirror)*

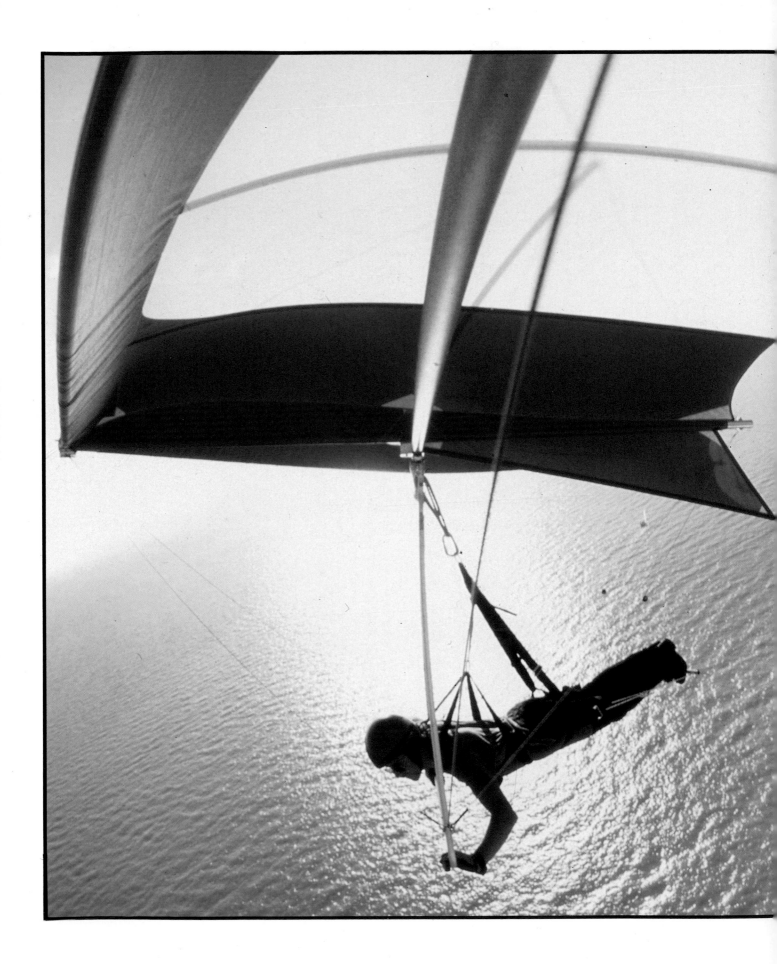

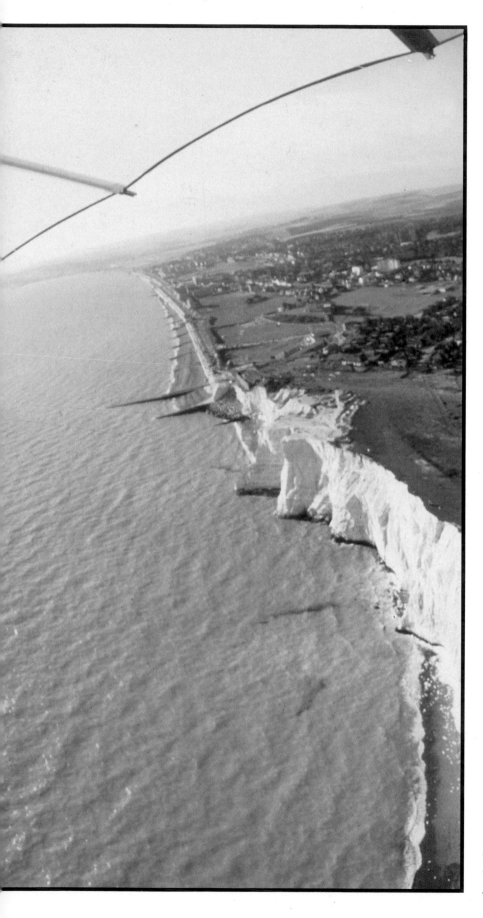

Up, up and away.... the hang-glider's view of Beachy Head *(Leo Mason)*

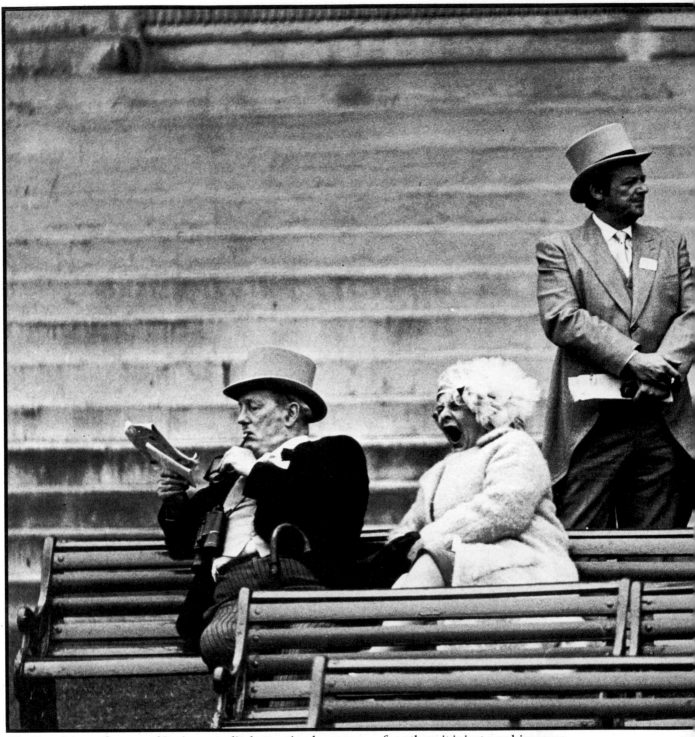

The Royal Ascot form card is given studied attention by some . . . for others it is just one big yawn

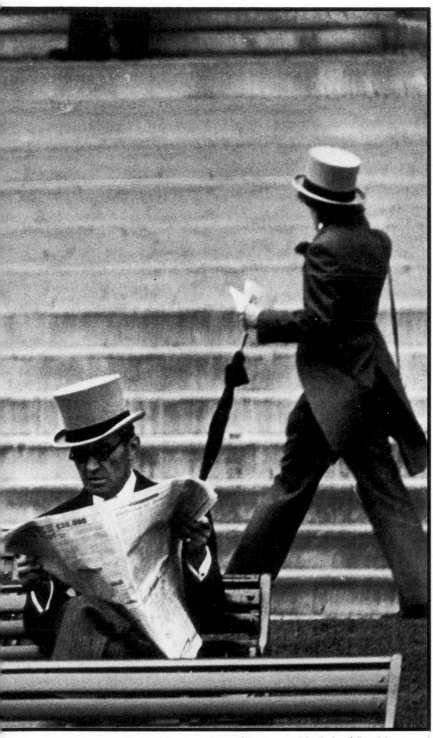

(Eamonn McCabe/The Observer)

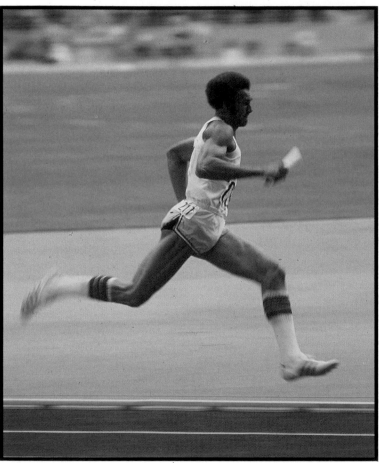

Cuba's Alberto Juantorena became the first Olympian to win
both the 400 and 800m at the same Games in Montreal
(Gerry Cranham)

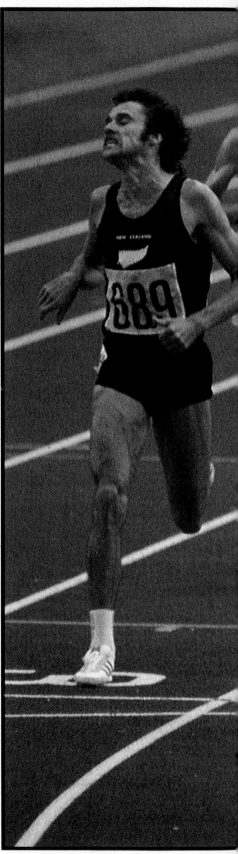

Finland's Lasse Viren completed a uniqu

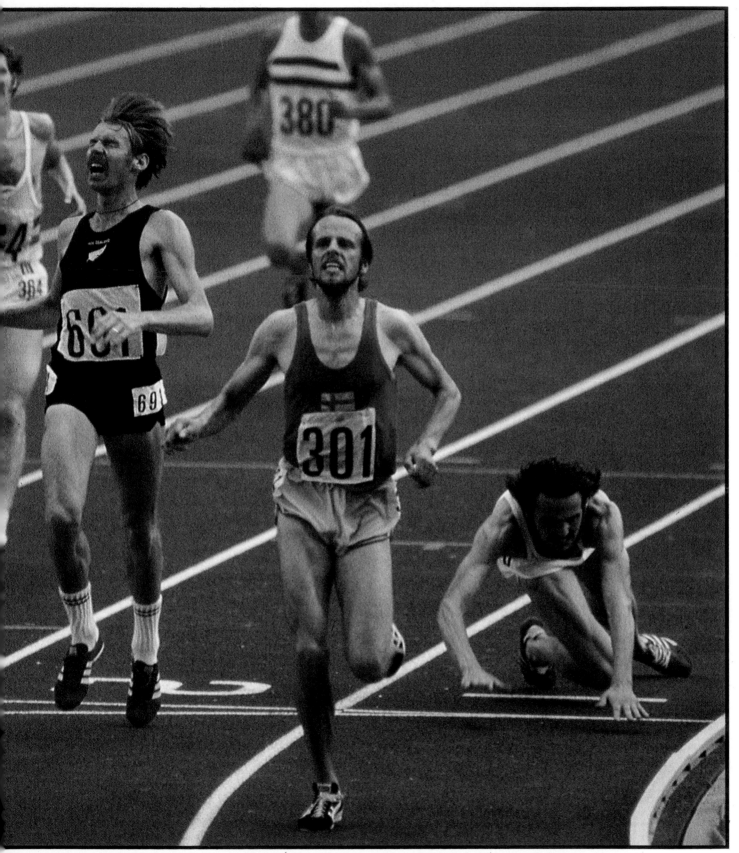

able in retaining both the 5,000 (above) and 10,000m Olympic titles in Montreal *(Tony Duffy/All-Sport)*

1977

Perhaps afraid that they would not be granted sight of the place again, Scottish football fans celebrated another Wembley victory over England by taking a good proportion of the pitch back with them and leaving the rest looking like Bannockburn after their other famous win over the auld enemy. Symbolically they also dug the soccer grave of England manager Don Revie, who shortly beat a somewhat dishonourable retreat to the desert of Dubai, Their fearsome battle-cry 'We're all part of Ally's Army' launched imitations all over the land as it roared on manager Ally McLeod's men to Scotland's second successive World Cup finals and the Army began saving its bawbees to follow their latter-day Bruce on an invasion of Argentina. England could only savour the achievements of League and European champions Liverpool, who just failed, with a 2-1 defeat by Manchester United, to add the FA Cup to what would have been a unique treble.

But horse-racing fans on both sides of the Border were able to join in roaring home the Queen's filly Dunferm-line to win both the Oaks and the St Leger in her Silver Jubilee year while her chirpy Royal jockey Willie Carson carried off the Jockey of the Year (some said Joker of the Year) title with another few hundred quick-fire words.

However, no doubt that the horse of the year was the 12-year-old Red Rum whose unprecedented third victory in the Grand National left most of his rivals somewhere in the vicinity of the Melling Road, including 21-year-old Charlotte Brew, first woman to ride in the event.

But few contests matched the nail-biting last 18 holes of the Open golf battle at Turnberry between the American giants Jack Nicklaus and Tom Watson. They matched each other drive for drive, recovery for recovery and putt for putt with no more than a stroke between them until Watson edged home in the greatest 'match' in medal-play history.

Hubert Green, who finished third, ten strokes behind Nicklaus, was moved to claim the title for himself. 'Those other guys were playing an entirely different game,' he said.

Alan Minter loses his gumshield – and his Europea

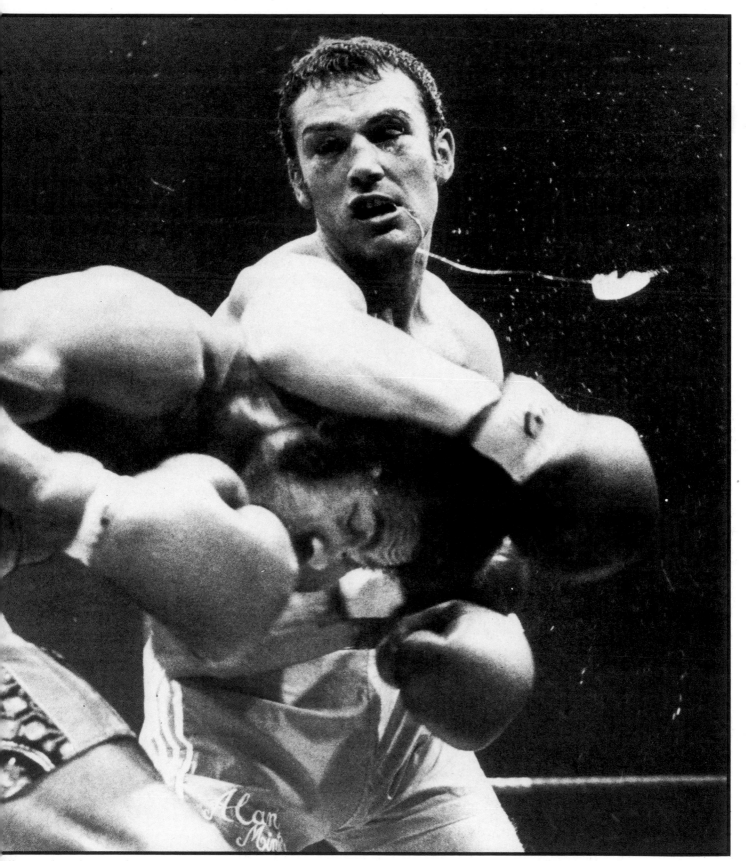

dleweight title soon followed suit when Frenchman Gratien Tonna cut him in the eighth round in Milan *(Peter Jay/The Sun)*

One of the premier occasions in a summer of sport . . . Glorious Goodwood *(Gerry Cranham)*

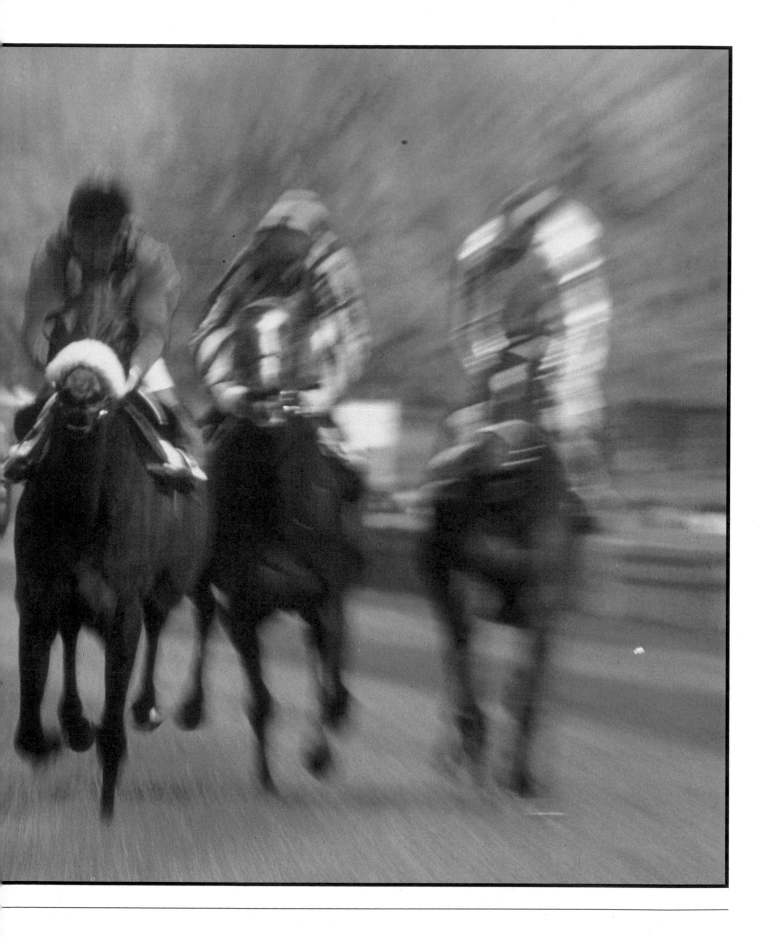

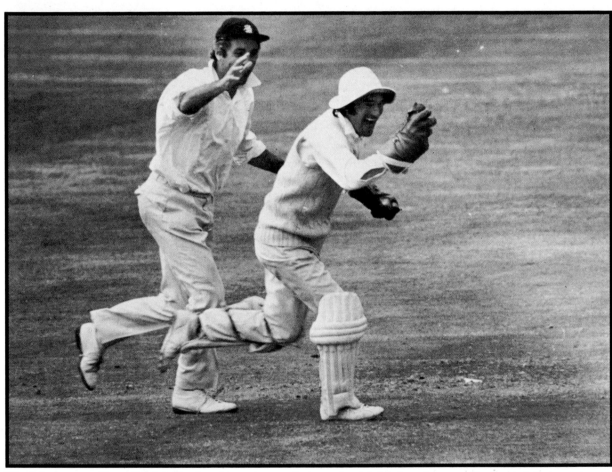

Like his stumps, Tony Greig's England career was shattered with his involvement in the cricket 'circus' set up by Kerry Packer in Australia. One of his recruits, wicket-keeper Alan Knott, stayed on long enough to help Greig's successor as England captain, Mike Brearley, win an Ashes series over Australia, then fled the country as well as the crowd *(Eric Piper/Daily Mirror)*

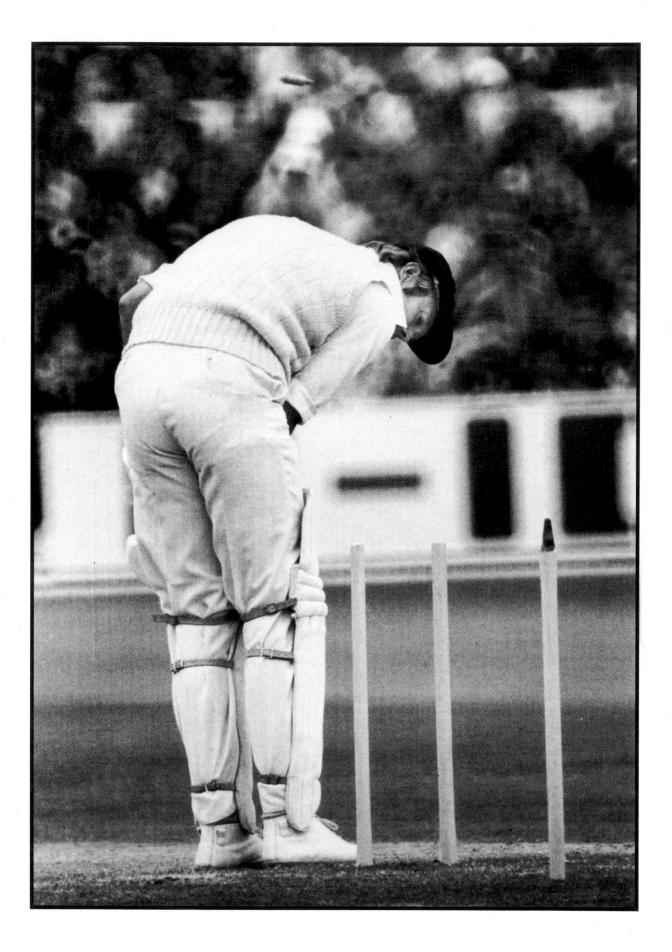

The weather matched the Lions much-changed team in New Zealand and a lot of good it did the likes of England's Fran Cotton and Scotland's Dougie Morgan *(Adrian Murrell/All-Sport), above, (Colin Elsey/Colorsport)*. The Lions lost the Test series 3–1, had their first provincial defeat for nine years and on the way home lost their first-ever game against Fiji.

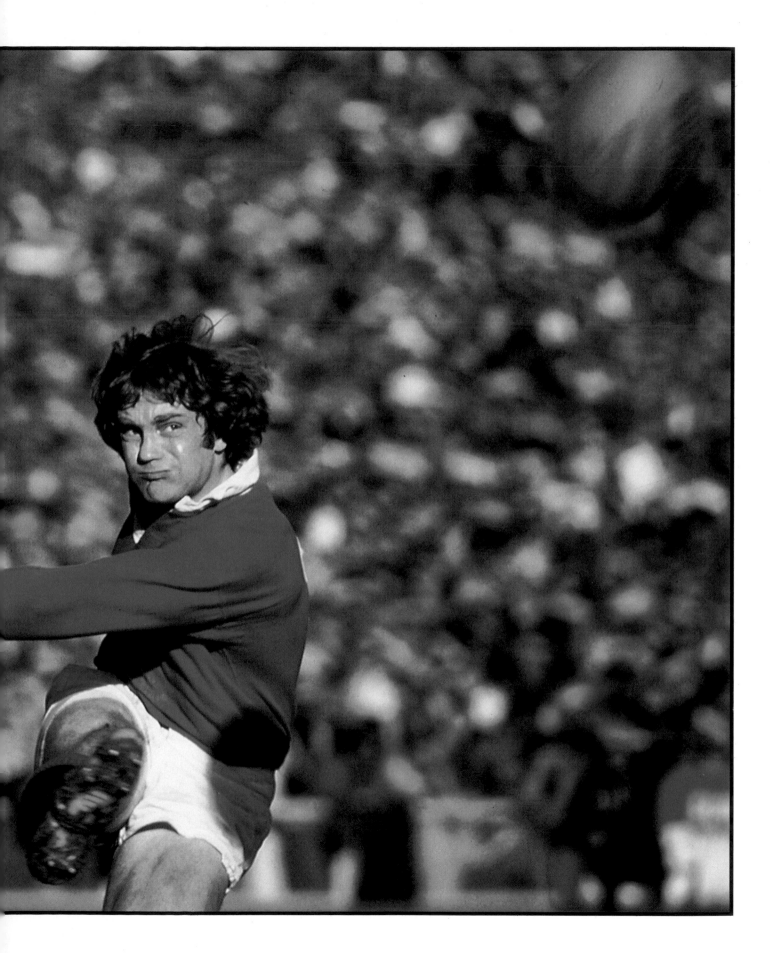

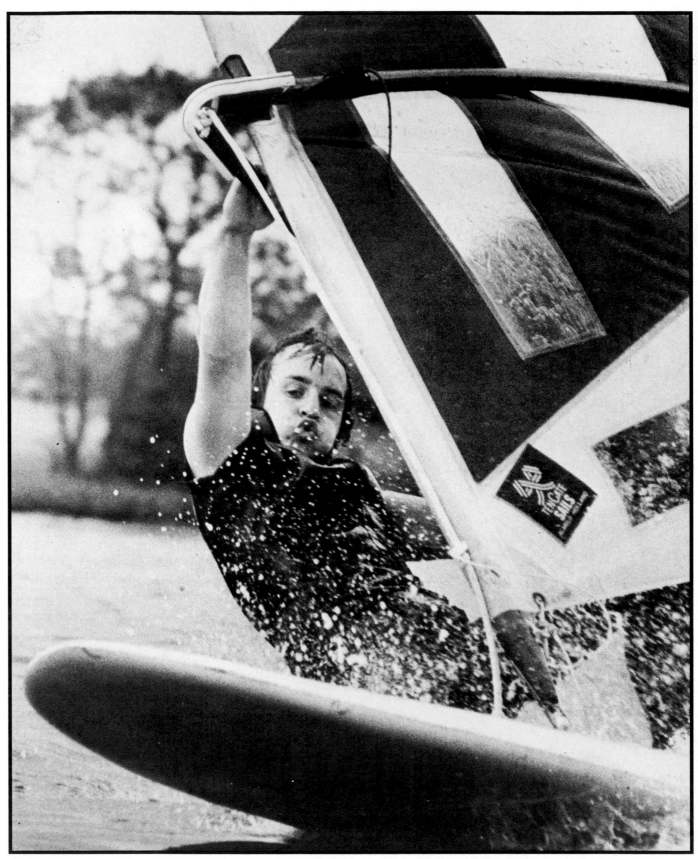

Wind-surfing . . . all about balance and concentration *(Roger Grayson/Mansfield Chronicle Advertiser)*

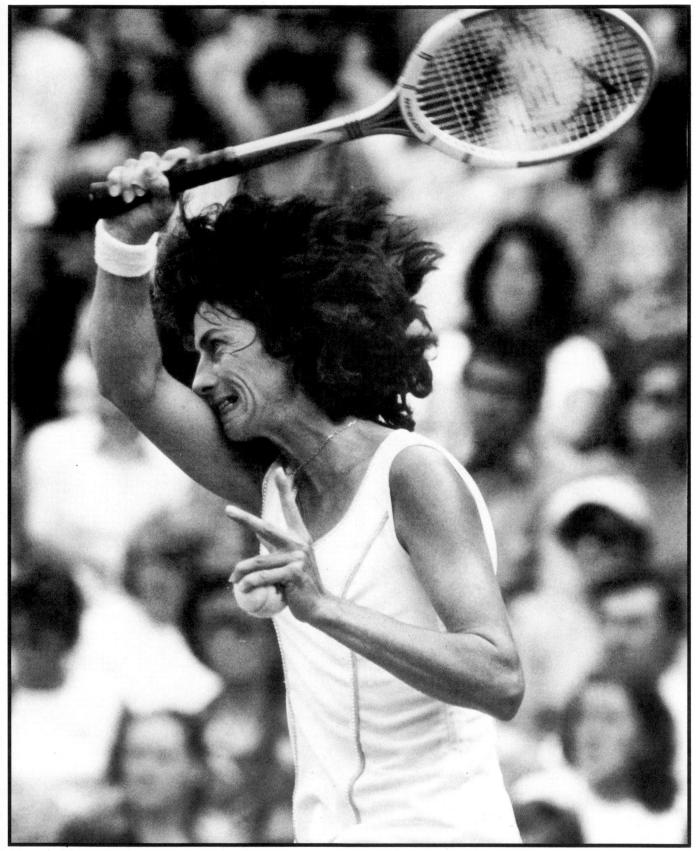

31-year-old Virginia Wade won Wimbledon in its Centenary Year after 15 years of trying *(Peter Jay/The Sun)*

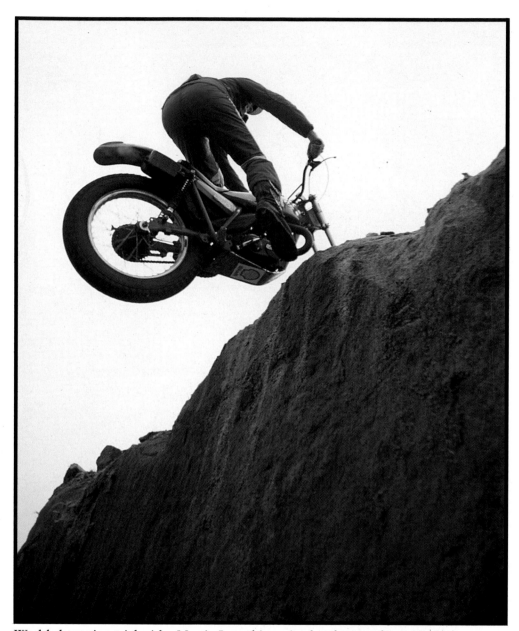

World champion trials rider Martin Lampkin poised at the top *(Don Morley)*

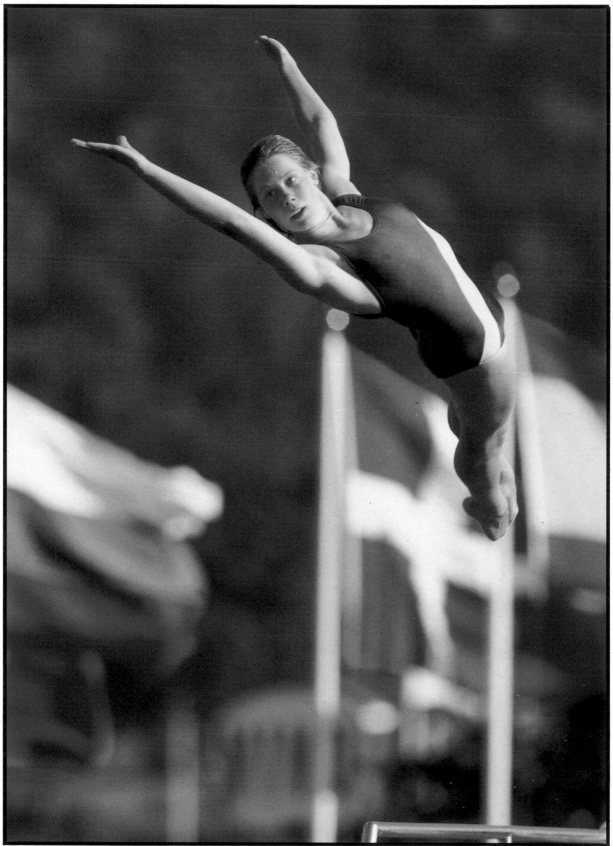

Diver Christine Jones flying the flag *(Tony Duffy/All-Sport)*

1978

'Land of My Fathers' rolled ever more passionately over Cardiff Arms Park, Twickenham and Lansdowne Road as Wales stormed to their second Grand Slam rugby union title in three seasons, but was also a farewell hymn of praise for four who had contributed more than most to the triumphs: captain Terry Cobner, flashing winger Gerald Davies, darting fly-half Phil Bennett, with international championship and world points-scoring records, and the incomparable Gareth Edwards with a record 53 consecutive appearances behind the scrum.

All retired, but left Wales with such a depth of talent that at the tail end of the year the Arms Park was again shuddering with song even in defeat. Beaten 12-10 only by a last-minute debatable penalty, Wales came closest to inflicting international defeat on the most successful All Blacks side to tour.

New Zealand also won a cricket Test against England for the first time in 47 years of endeavour, turning sour the achievement of a lifetime's ambition by Geoffrey Boycott, who captained England for the first time. Deprived of even the vice-captaincy when the 1978-79 tour party to Australia was announced, Boycott was also shortly relieved of the Yorkshire captaincy after eight years, provoking yet another huge public cricket row in the county.

The man equally as controversial in English football, Brian Clough, began to get his act together at Nottingham Forest, his fourth club in almost as many years, steering them to their first League title and joining Liverpool, the first British club to retain the Champions Cup, in Europe.

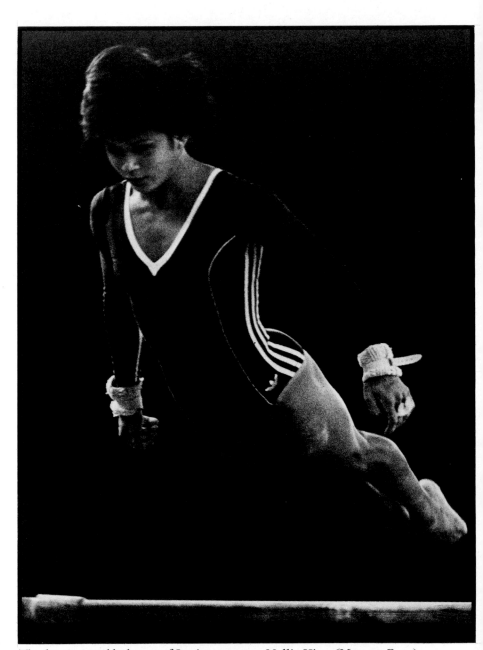

The beauty and balance of Soviet gymnast Nellie Kim *(Mervyn Rees)*

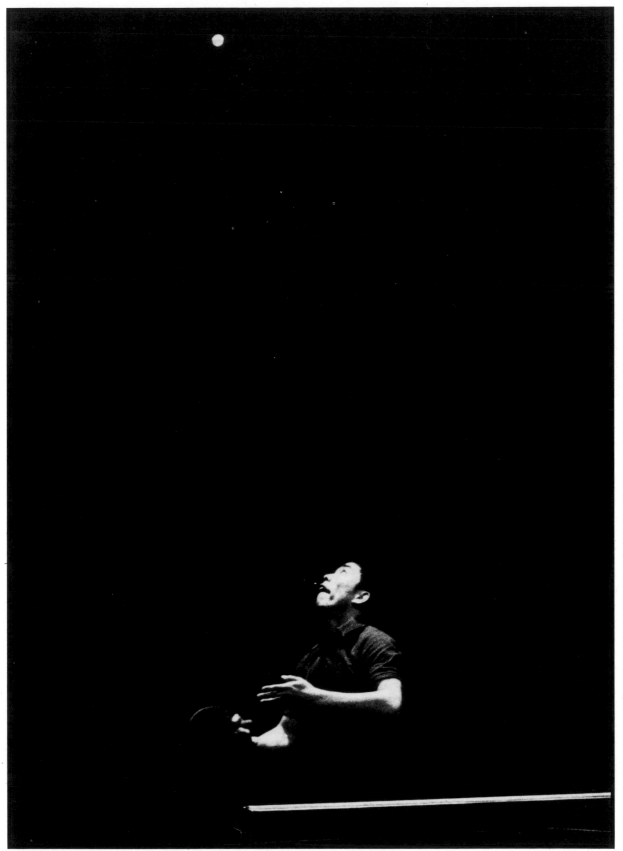

High serving table tennis tactics *(Eamonn McCabe/The Observer)*

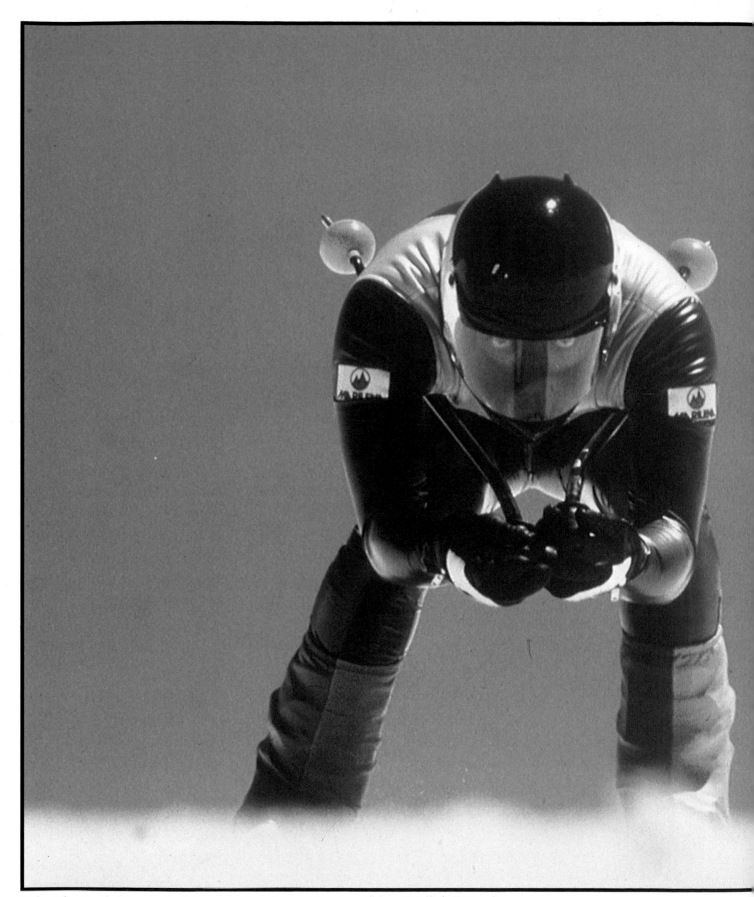

125 mph speed skiing in the Kilometre Lanciana at Les Arcs (*Tony Duffy/All-Sport*)

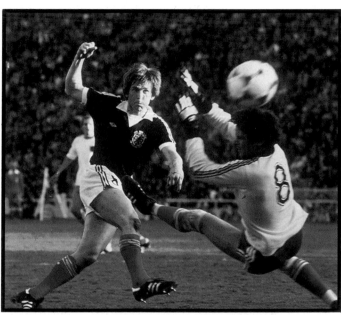

Scotland's Kenny Dalglish beats Dutch goalkeeper
Jongbloed in the Argentine World Cup finals –
Scotland's only success in an otherwise disastrous trip.
Disappointing also for the Dutch who lost to the host
country in the final for the second successive
tournament *(John Varley/Daily Mirror)*

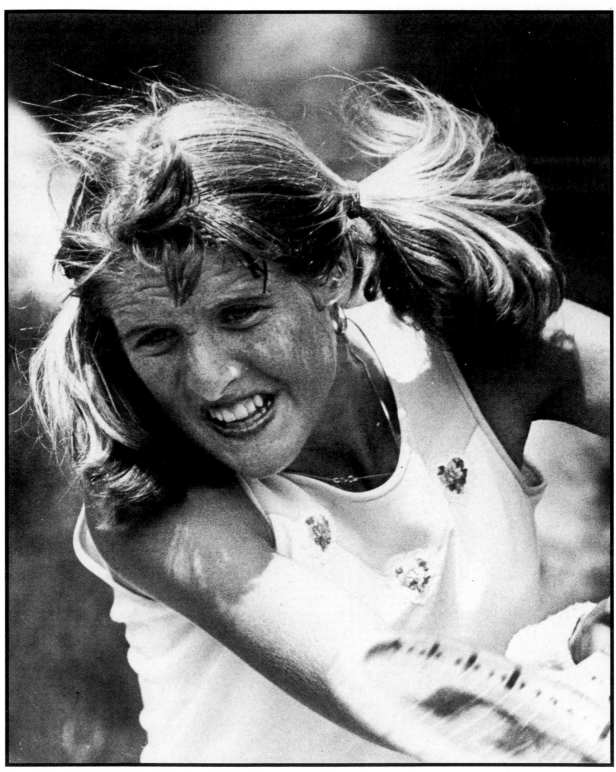

Tracy 'The Pig-Tail Prodigy' Austin, at 15 a winner over Navratilova and quarter-finalist at both Wimbledon and the US Open, before turning pro at the end of the year *(Mervyn Rees)*

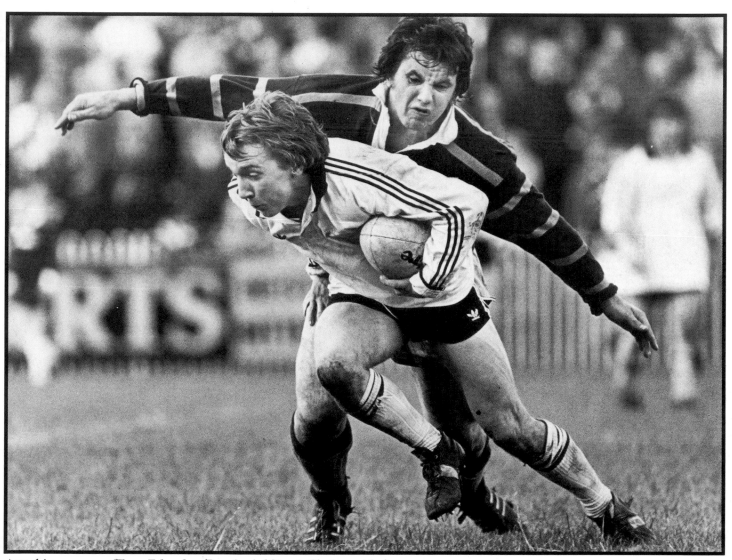

Attacking swoop *(Tony Edenden/Provincial Sports Photography)*

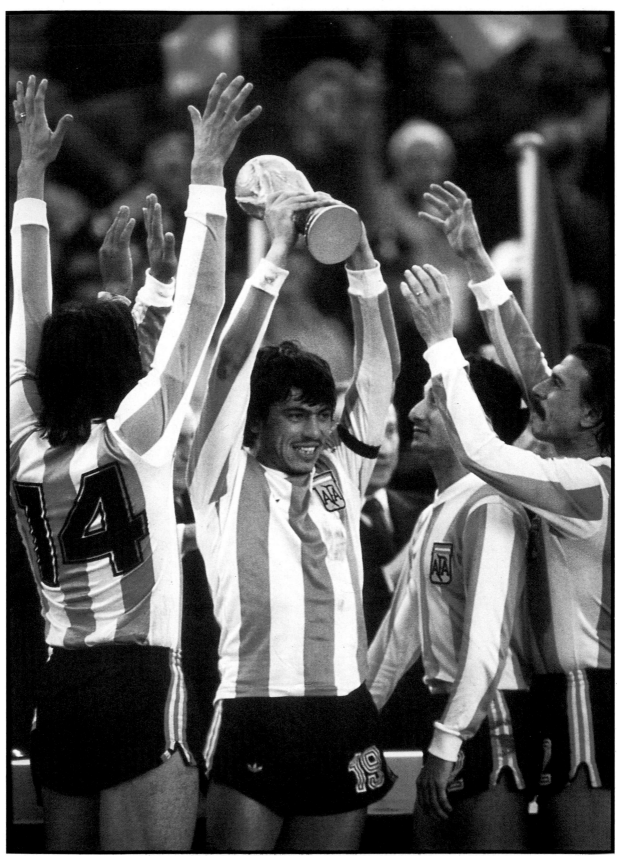

Argentine captain Daniel Passarella with the World Cup trophy *(Stewart Fraser/Colorsport)*

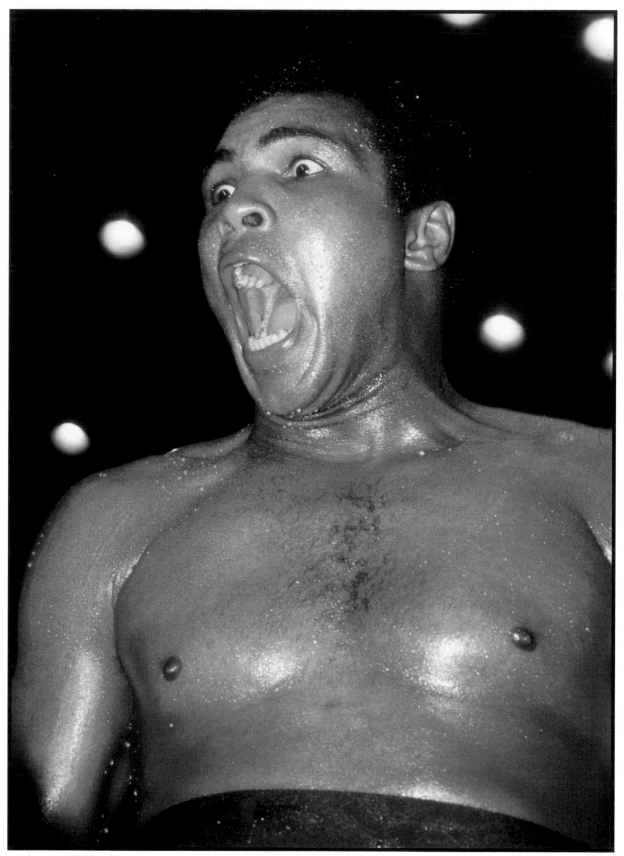

Muhammad Ali – the first to win the world heavyweight title three times *(Andy Cowie/Colorsport)*

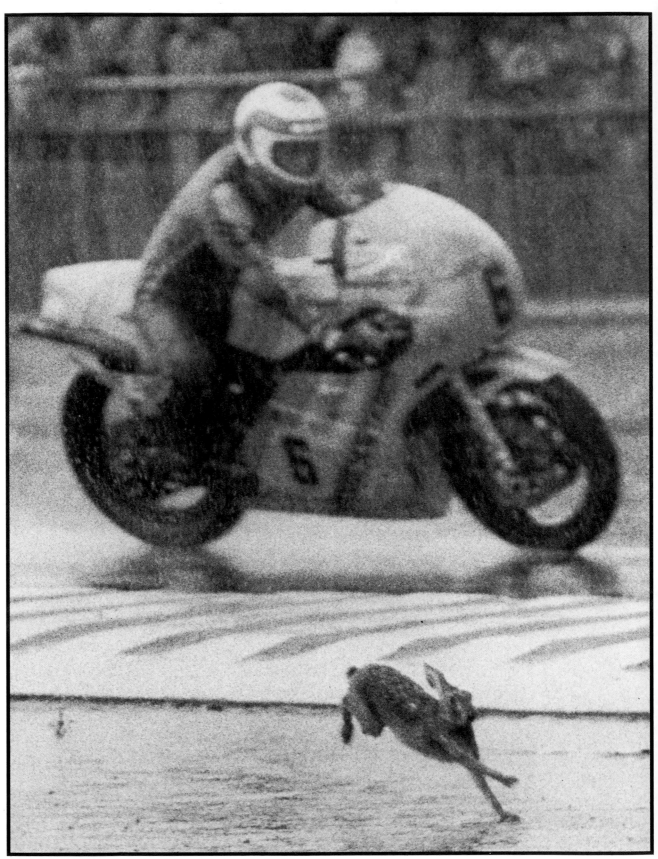

Harey Moment in the rain *(Albert Foster/Daily Mirror)*

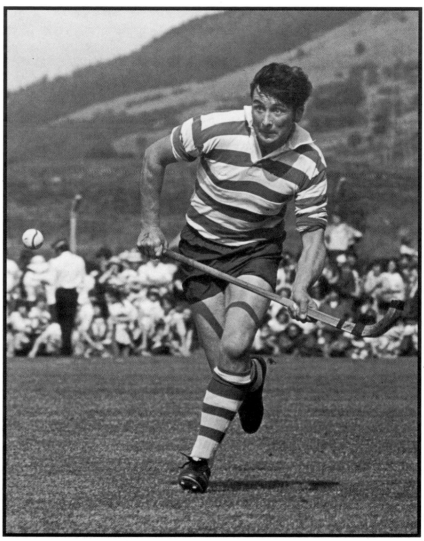

John McKenzie of Newtonmore on the ball during the shinty
Camanachd Cup Final at Fort William (*Donald McKay*)

1979

There is sometimes the odd year in a decade when sports editors and their acolytes open their brand-new diaries and are faced with the appalling prospect of what they consider a 'quiet time' ahead. No Olympic Games, World Cups, Commonwealth Games, Ashes Tests, or world title fights in prospect. Just the 'routine' rugby, soccer cups, Grand National, Derby, Open golf, Wimbledon, motorracing, swimming championships, athletics internationals and all that jazz. The sort of year when Princess Anne would decide to take up Fell walking.

'Seventy-Nine began quietly enough. Australia were humiliated as England retained the Ashes, suffering five defeats at home for the first time and bringing about a reconciliation with Kerry Packer. Brian Clough made Trevor Francis Britain's first £1 million footballer and he scored the goal which won them the European Cup. Liverpool duly won the League title for the third time in four seasons with a clutch of new points and scoring records, although Arsenal and Manchester United did put unusual life into the Cup Final between them scoring three times in the last four minutes.

It looked like being a 'so what's new?' summer until a young American jockey named Steve Cauthen arrived to continue his winning ways in England; a Spanish golfer named Severiano Ballesteros became the youngest to win the Open, Martina Navratilova got her mother out of Czechoslovakia for the first time to see her win Wimbledon again and partner the veteran Billy-Jean King to a record 20th title in the doubles (on the day after the previous holder, 88-year-old Elizabeth Ryan, had collapsed and died at the Centre Court); John McEnroe, 20 and Tracey Austin, 16 going on 17, became the youngest to win their respective US Open tennis titles; and Sebastian Coe and Steve Ovett set the scribes and snappers zig-zagging across Europe while they took some world track records apart.

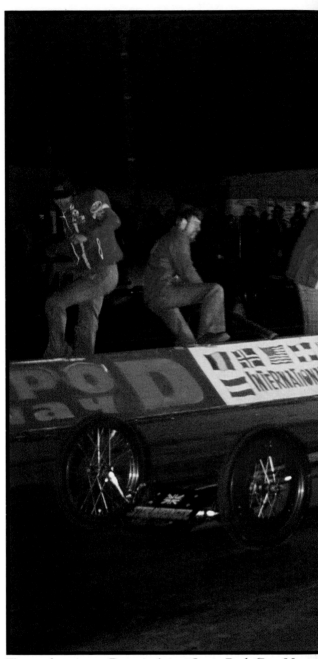

Fire and power – Drag racing at Santa Pod (*Leo Mason*

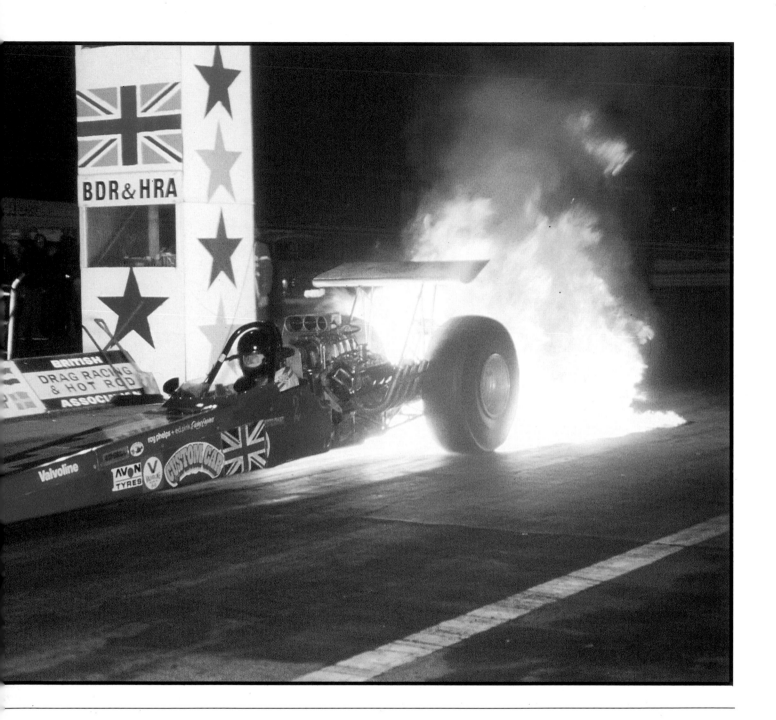

Giving them the eye . . . Rugby prop-forward Clint McGregor lines up for Middlesex; Bjorn Borg seemed unbeatable at Wimbledon – winning for the record fourth successive year *(Eamonn McCabe/The Observer)*

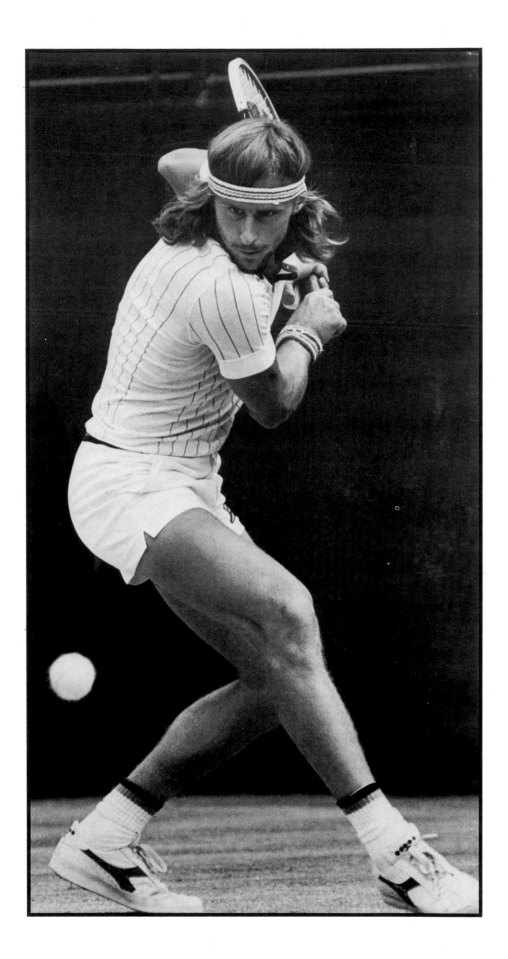

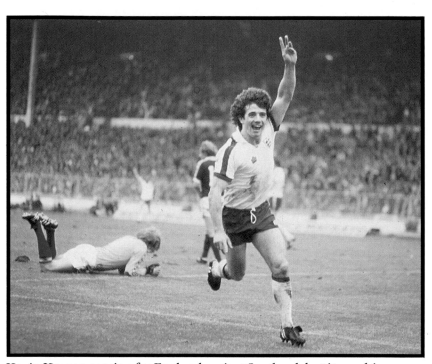

Kevin Keegan scoring for England against Scotland, but it was his play mainly for Hamburg FC which made him the first Englishman to retain the 'European Footballer of The Year' title
(Steve Powell/All-Sport)

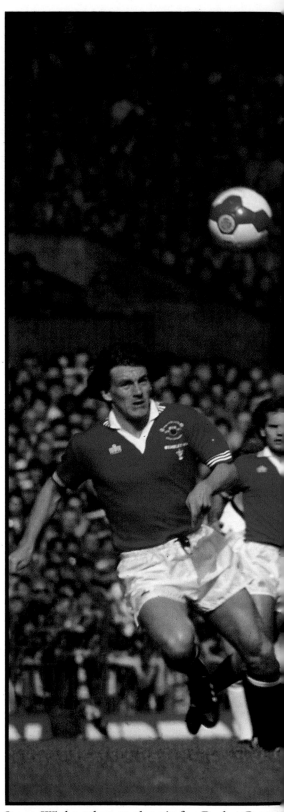

Steve Wicks takes to the air for Derby Count

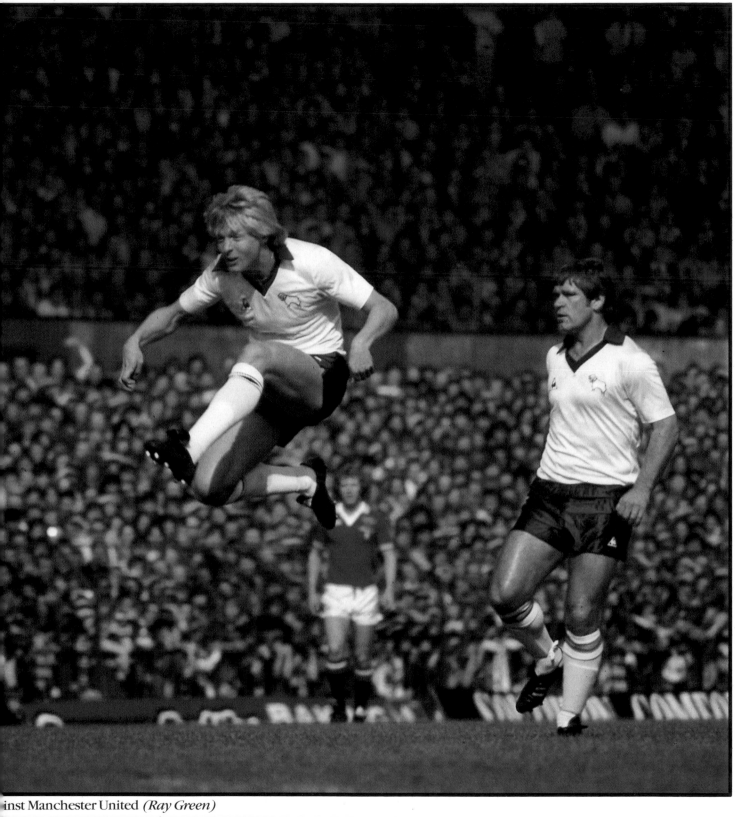

inst Manchester United *(Ray Green)*

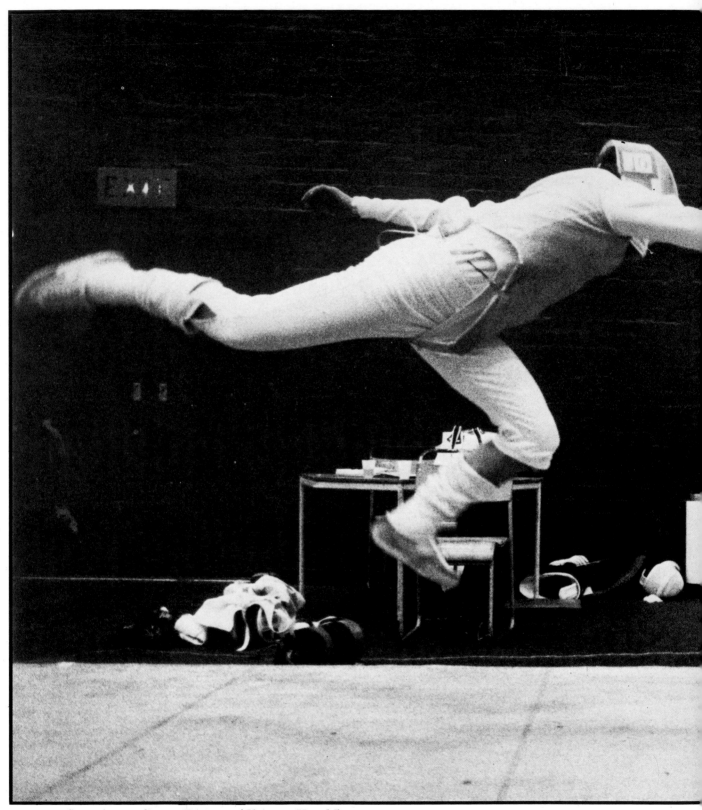

Fencing's flying lunge *(Stuart Paterson/Glasgow Herald)*

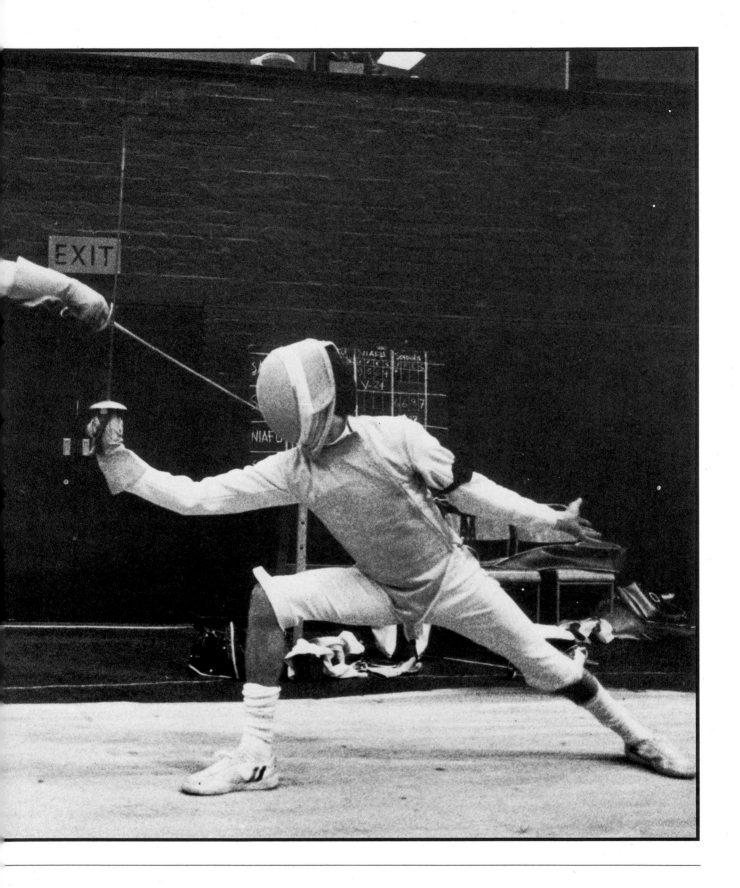

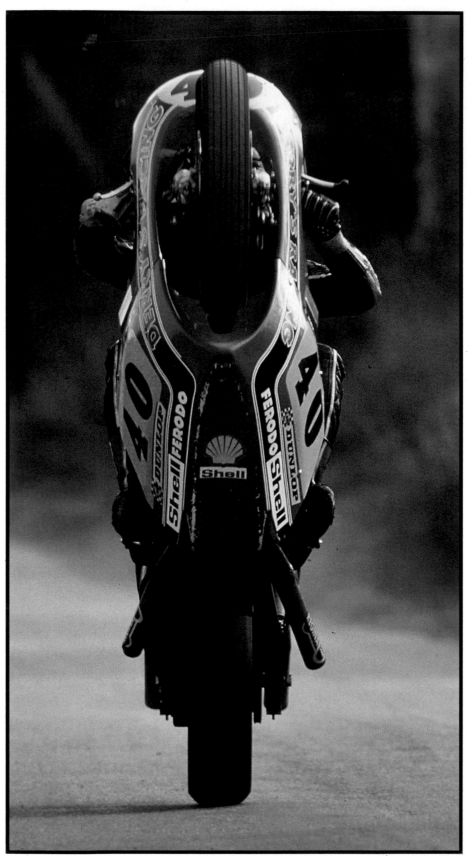

Dennis Ireland, world championship contender in 500cc class *(Don Morley)*

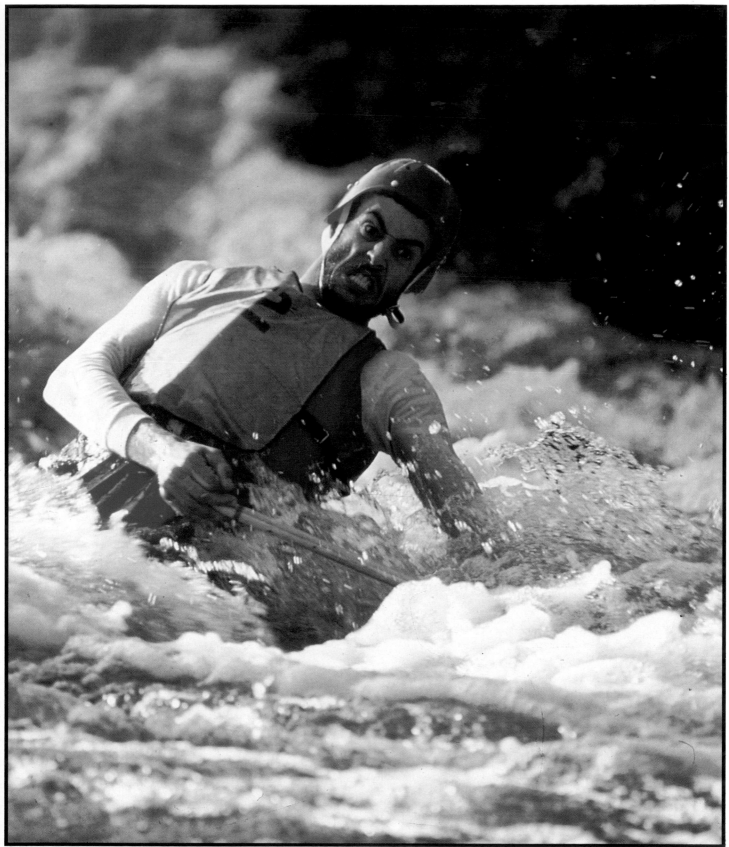

Winning on the wild waters *(Leo Mason)*

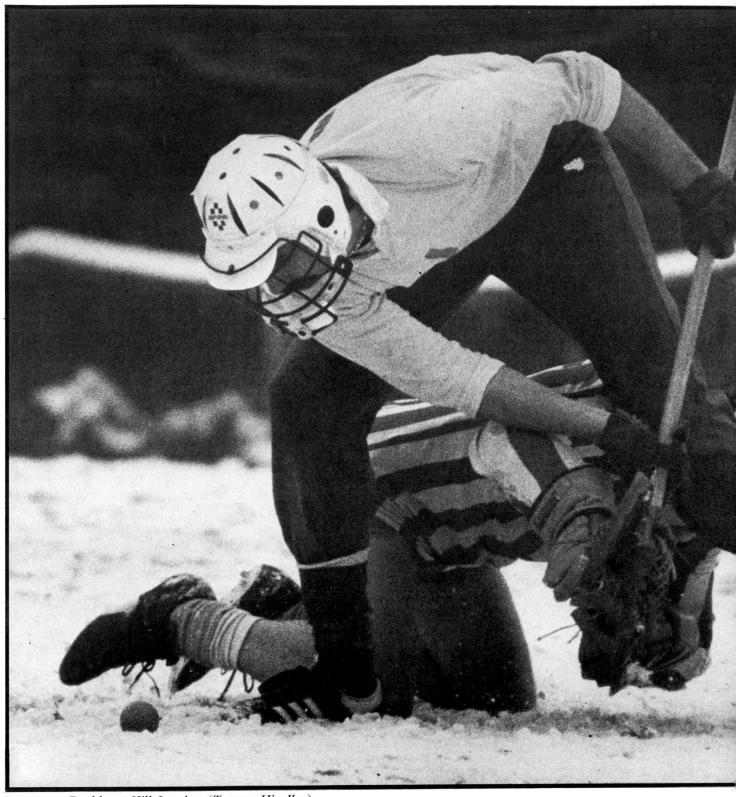

Lacrosse at Buckhurst Hill, London (*Tommy Hindley*)

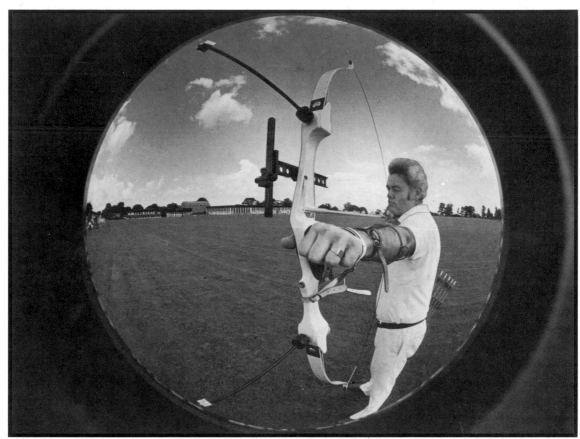

Calum Miller, former Scottish archery champion and his high-tech bow (*Stuart Paterson/Glasgow Herald*)

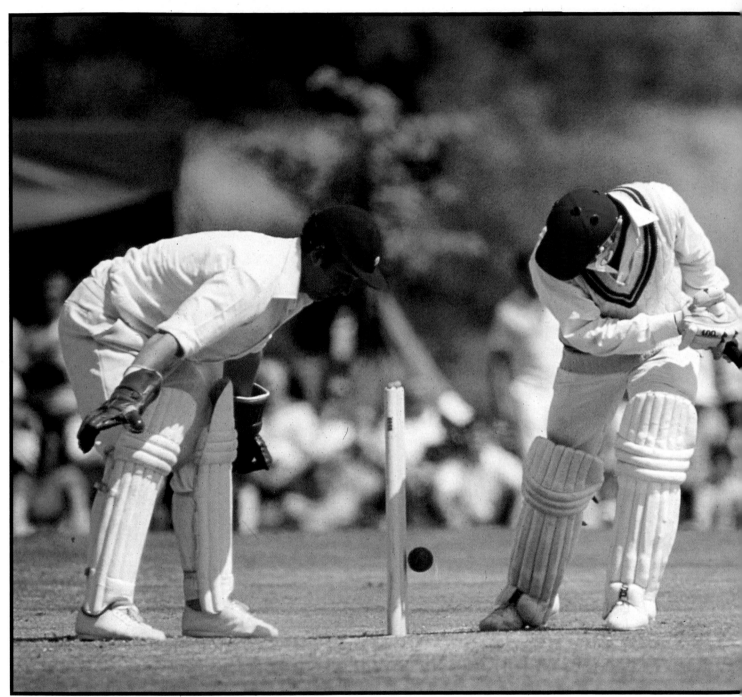

Amazingly, the bails stayed on for the West Indies batsman Bacchus against Northamptonshire *(Bob Thomas)*

1980

Afghanistan, never a name to encourage dreams of past Olympic glory, was the innocent perpetrator of the most controversial of all the modern Olympiads after it had been invaded by the USSR, hosts to the Summer Olympics in Moscow. President Carter virtually ordered the United States not to attend and Prime Minister Margaret Thatcher tried, not so successfully, to get the British Olympic Association to boycott the Games. In the event, only 81 nations – the lowest attendance for 24 years – made the trip.

One who declined to leave the world stage, although advised on all sides to do so was erstwhile world heavy-weight boxing champion Muhammad Ali, who made a fourth attempt to lift the title conceding nearly 10 years to Larry Holmes, who after-wards admitted it was 'embarrassing' for him to have to hit a hugely overweight Ali. But a happier and more successful 'comeback' was made by the 40-year-old 'Golden Bear' Jack Nicklaus, who won both the US Open and US PGA championships to bring his total of major titles to 17 in his 19 years as a pro. Appropriately the achievement came on the 50th anniversary of the only golfing feat Nicklaus has not equalled or beaten – the Grand Slam of US and British Open and Amateur titles by his legendary compatriot Bobby Jones.

Everyone who has helped bookmakers stay out of the Job Centres has heard to their cost of three-legged horses, but nobody complained about Henbit which won the 201st running of the Derby after cracking a cannon-bone with 200 yards to go.

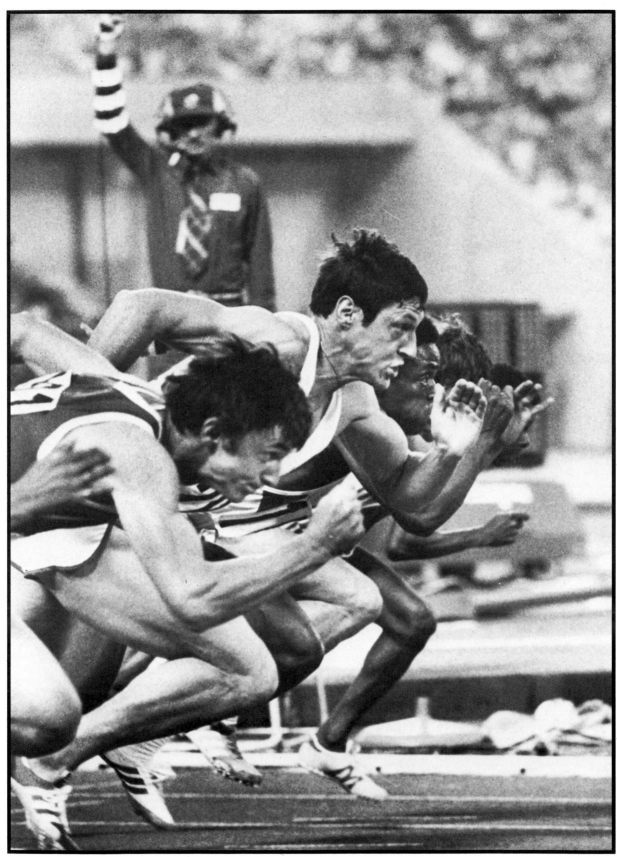

Scotland's Allan Wells on his way to becoming the first Britisher since
Harold Abrahams in 1924 to win the Olympic 100 metres title *(Chris Smith/Sunday Times)*

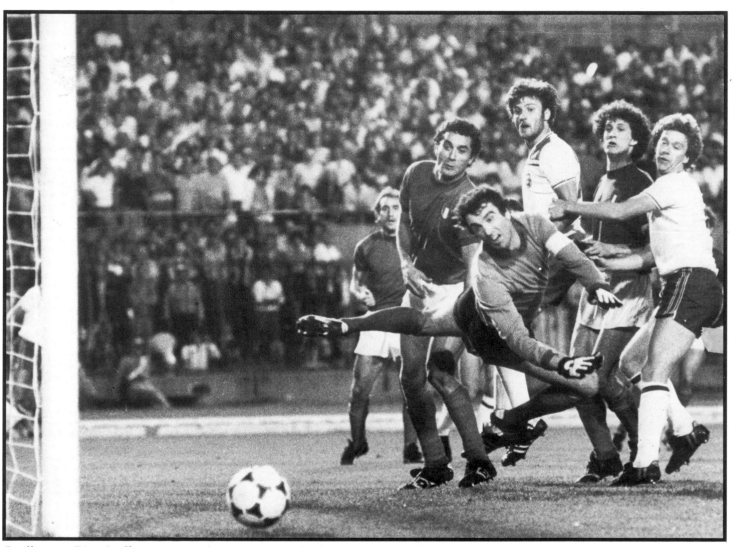

Goalkeeper Dino Zoff, soon to reach 100 caps and skipper Italy to World Cup victory, holds off England challengers Tony Woodcock and Gary Birtles in the European championship finals *(John Dawes/Daily Star)*

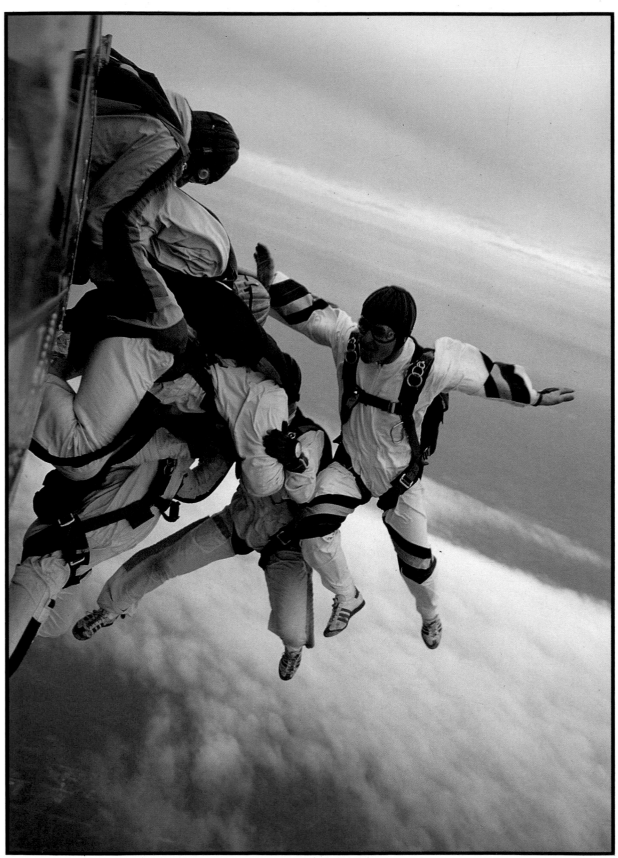

Britain's parachuting team in serious training *(Dave Waterman)*

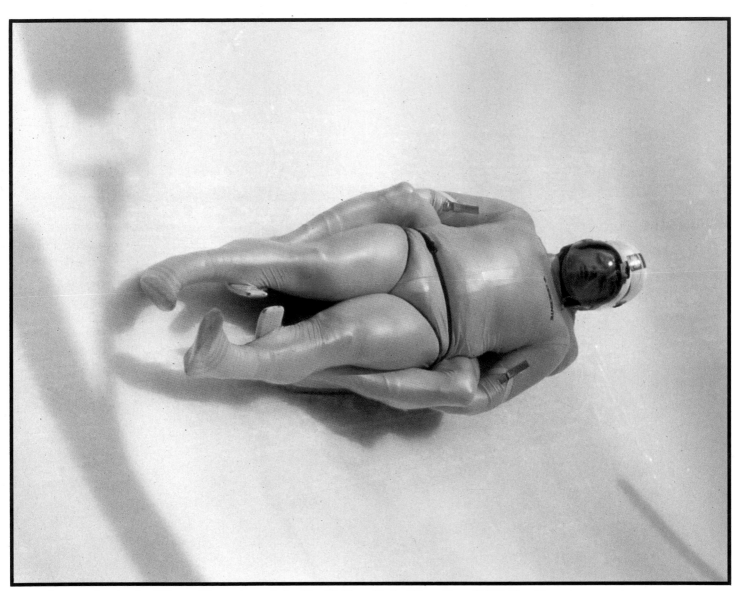
2-man luge action in the Winter Olympics at Lake Placid, New York *(Steve Powell/All-Sport)*

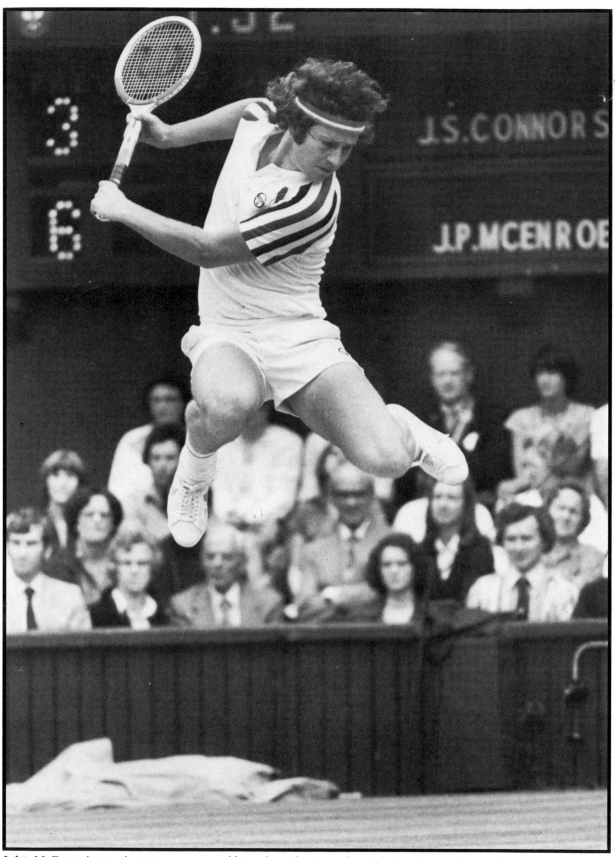

John McEnroe's tennis tantrums earned him the title 'Superbrat' *(John Dawes/Daily Star)*

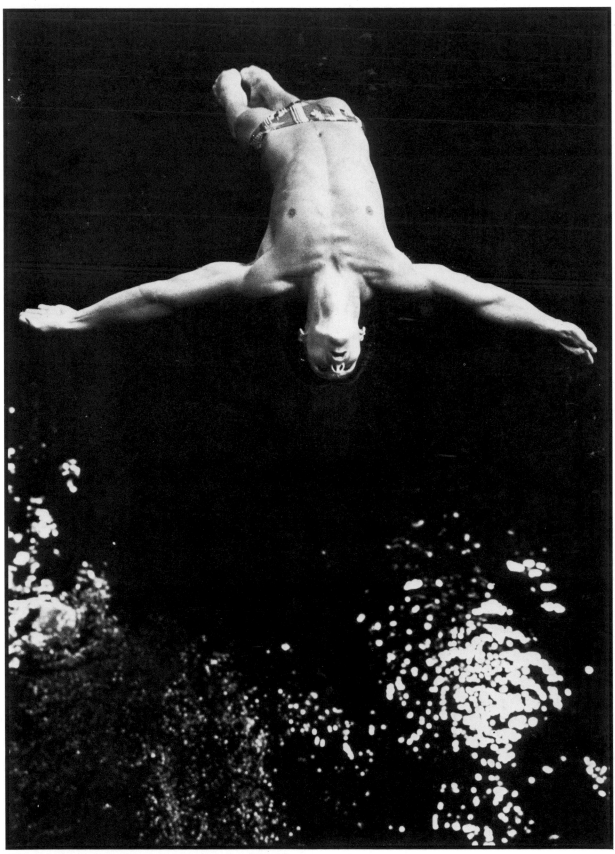

Olympic high dive *(Chris Smith/Sunday Times)*

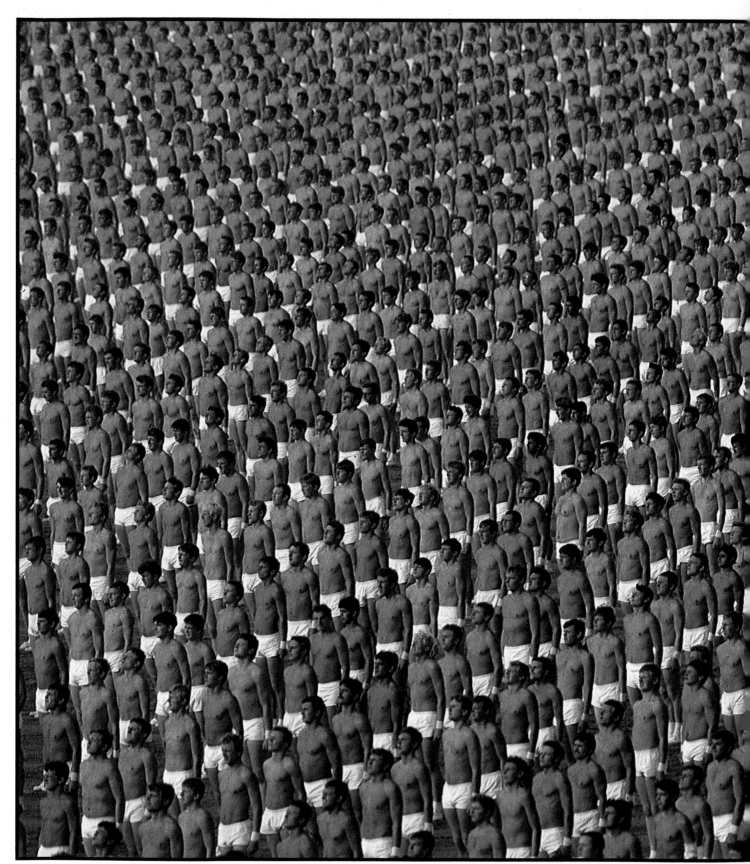

10,000 soldiers in near-perfect co-ordination during Spartakiade display in Prague *(Stewart Fraser/Colorsport)*

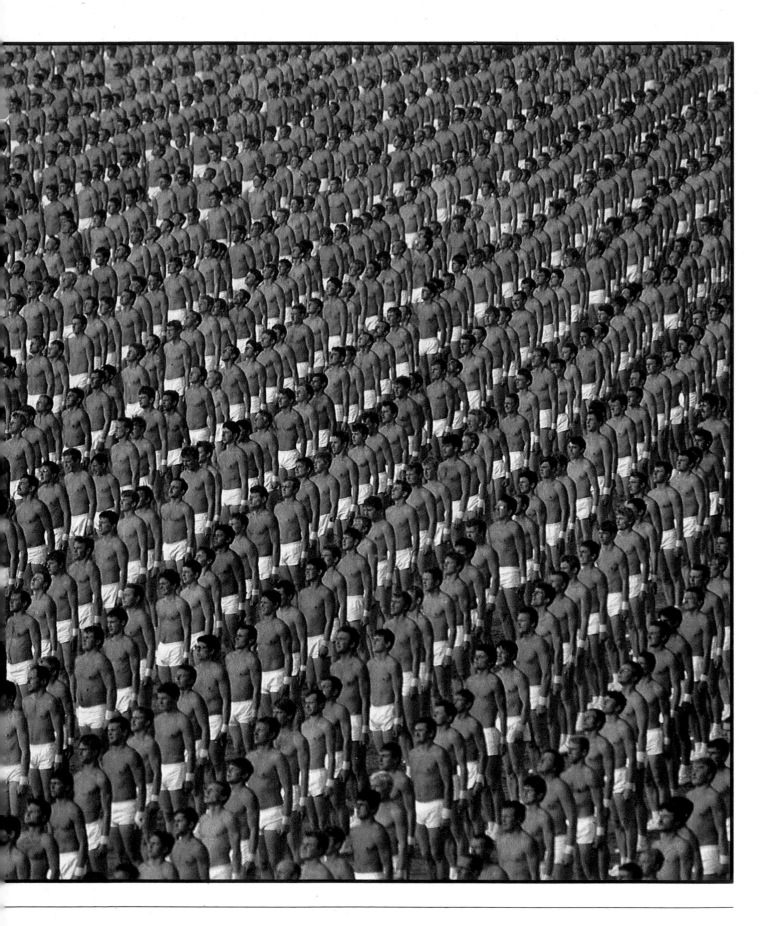

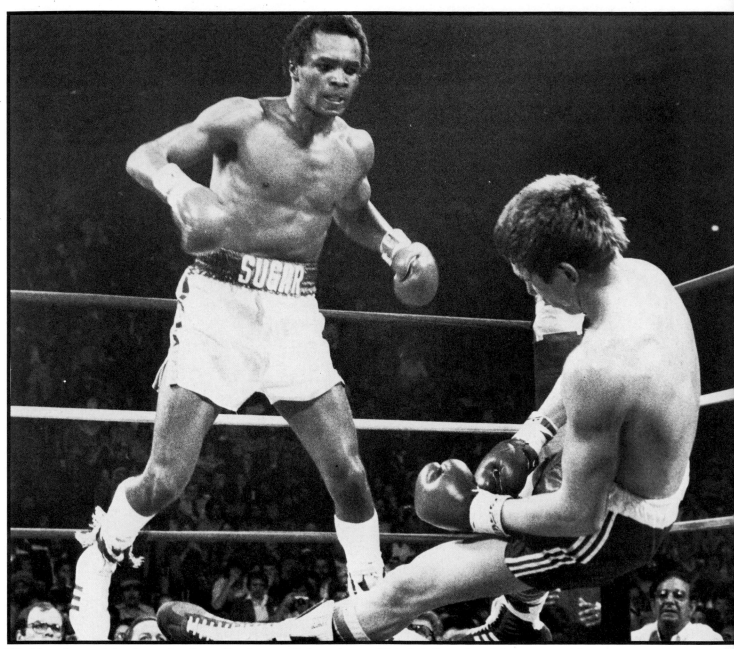

World welterweight champion Sugar Ray Leonard's knockout of Britain's Dave 'Boy' Green was only a step towards two classic encounters with Panama's Roberto Duran later in the year which at over $35 million a shot were the richest in history and made multi-millionaires of them both *(Monte Fresco/Daily Mirror)*

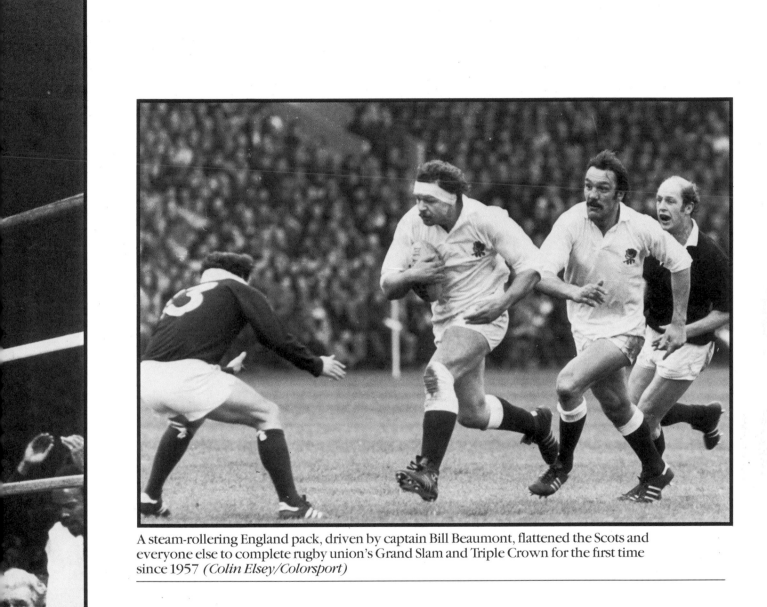

A steam-rollering England pack, driven by captain Bill Beaumont, flattened the Scots and everyone else to complete rugby union's Grand Slam and Triple Crown for the first time since 1957 *(Colin Elsey/Colorsport)*

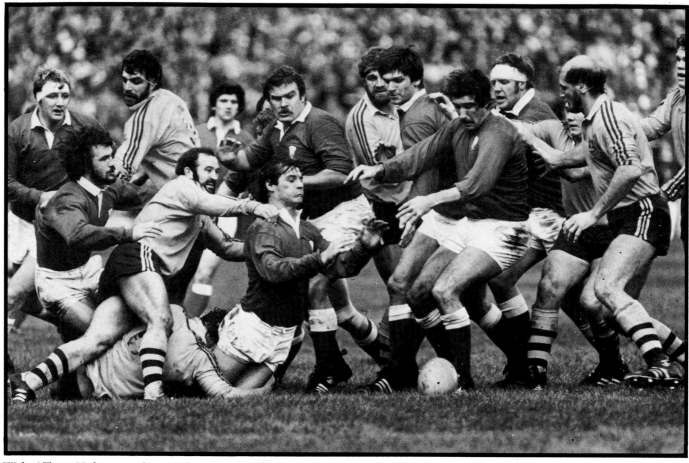

Wales' Terry Holmes took some holding. The touring Australians' restraint was only temporary *(Eamonn McCabe/The Observer)*

1981

The back pages gave the front pages some of their biggest and best headlines from very early on in the year when the Australian cricket captain Greg Chappell forced his young brother Trevor to revert to underarm bowling to avoid a tie in a Test. But that was nothing compared to the destruction of Australia later in the summer by Ian Botham and Bob Willis under the captaincy of Mike Brearley. The record books had to be re-written in all directions after England came back to win the Ashes after being one down and needing 91 runs to avoid an innings defeat. Then there was Derbyshire, winning both the semi-final and final of the Nat West Trophy with singles off the last balls which tied the games but gave them victory on fewer wickets lost.

The marathon craze, born of a keep-fit world which had discovered – or been sold – the joys of jogging, hit London with some 7,000 traversing the route between Greenwich and Constitution Hill. But for triumph over adversity, the Grand National had it all – won by a horse, Aldaniti, which had been lame, had a broken leg and should long before have been written off as a cripple, ridden by a jockey, Bob Champion, who 18 months before had been undergoing long and painful treatment for cancer.

Appropriately on American Independence Day, July 4, John McEnroe finally deprived Bjorn Borg of his Wimbledon singles title – the Swede's first defeat in 42 consecutive matches in his record 5-year run.

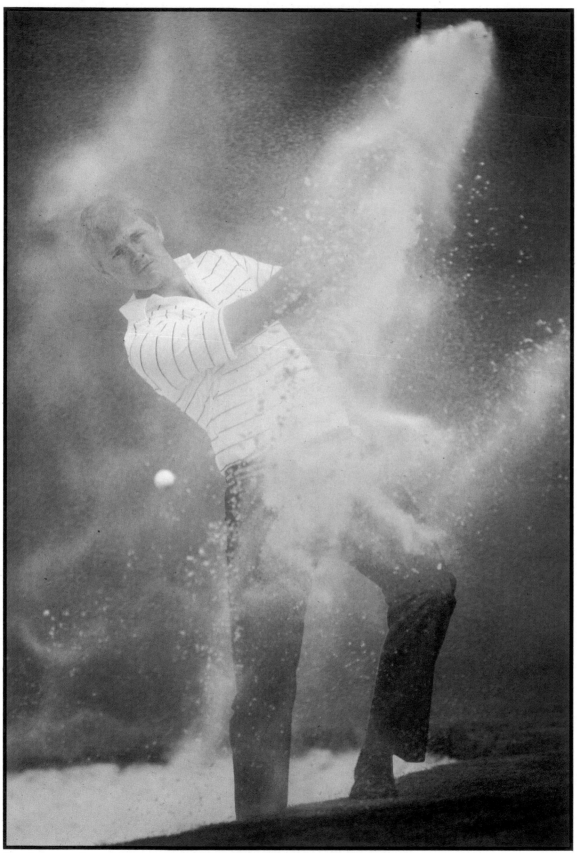

Getting out of trouble during the US Masters at Augusta *(Phil Sheldon)*

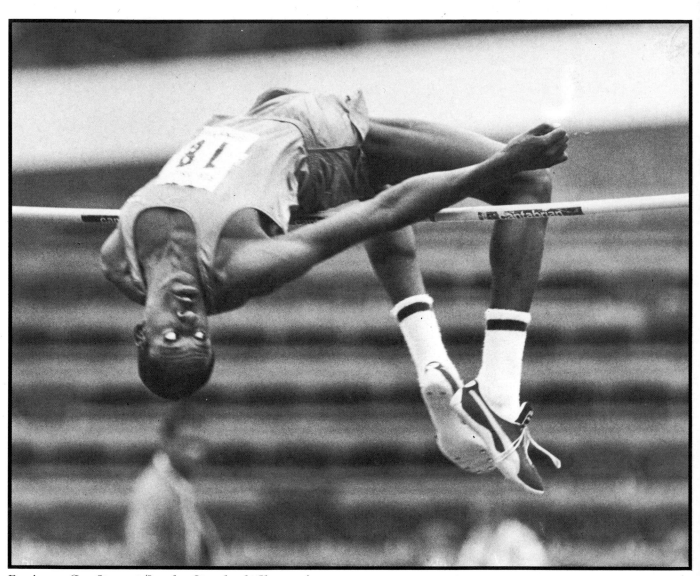

Eye jump *(Ian Stewart/Sunday Standard, Glasgow)*

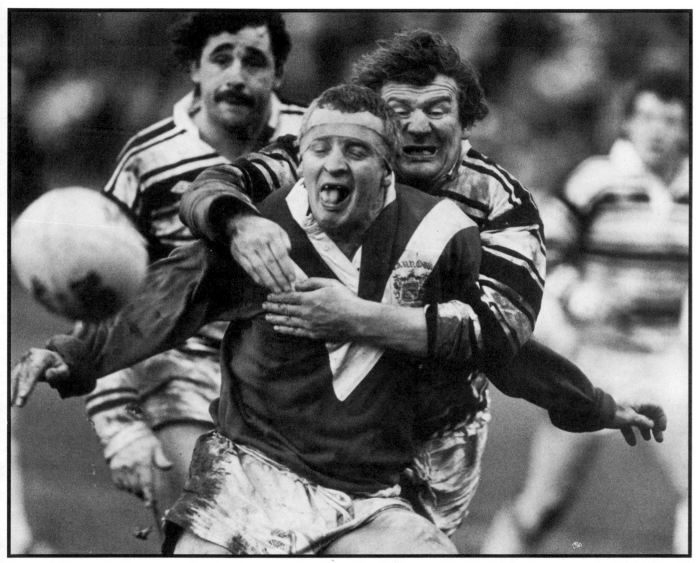

Barrow's Howard Allen passes despite close attention from Charlie Stone of Hull in Rugby League contest *(Mike Brett)*

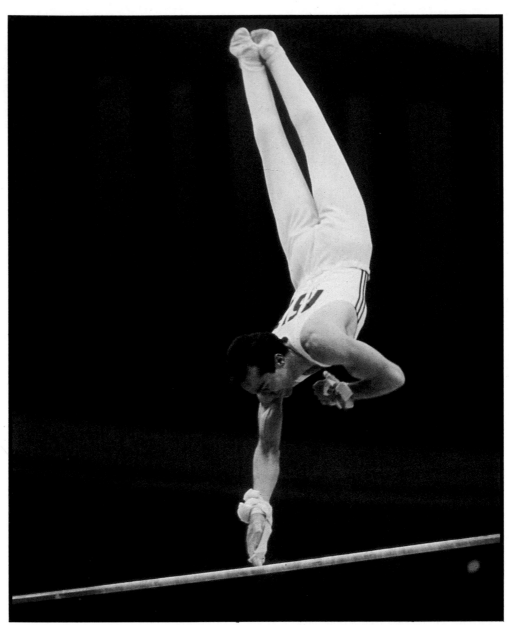

Fingertip control *(Eileen Langsley)*

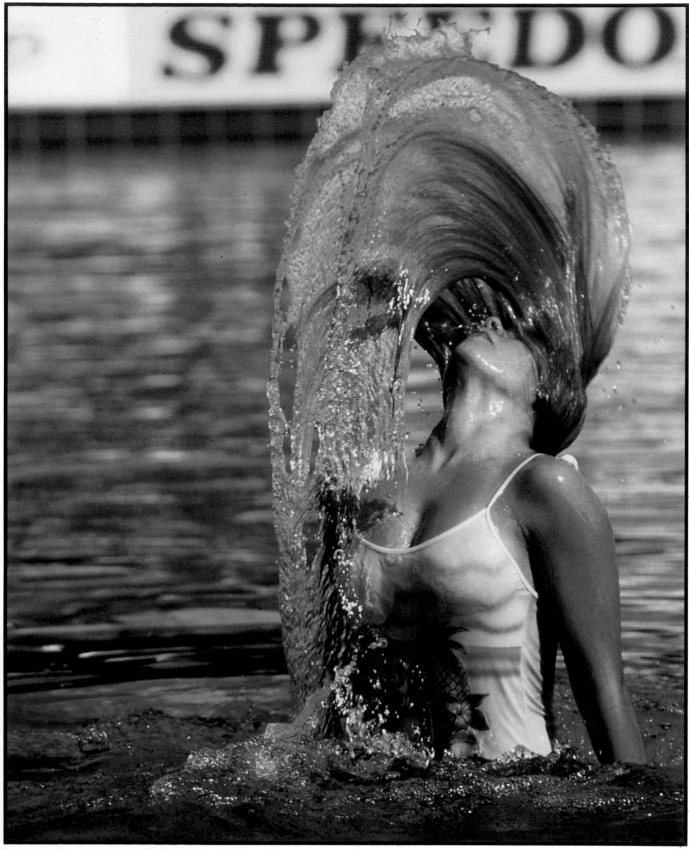

Swish swimmer *(Tony Duffy/All-Sport)*

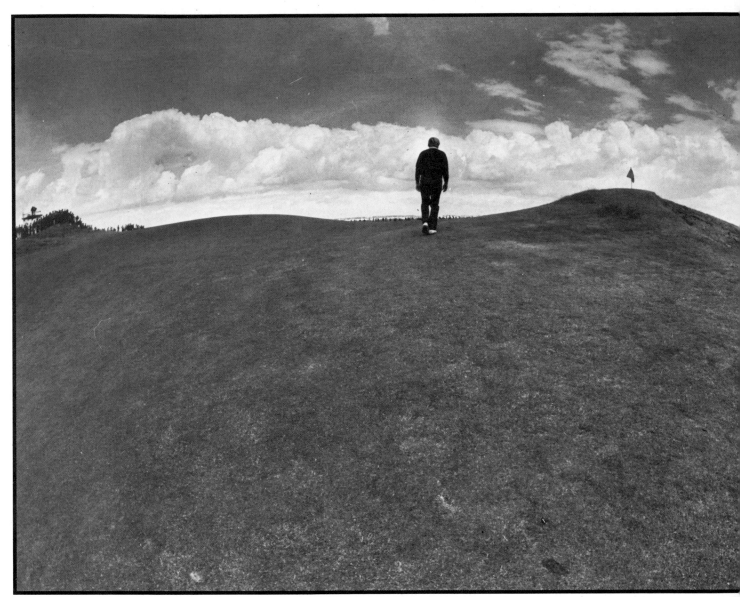

Jack Nicklaus, three times Open champion, played like an ordinary mortal for once, humbled by
the Royal St George's course at Sandwich, Kent, into an 83 – his highest in 19 years of championship
golf. But, typically, next day Nicklaus hit back with a 66 – equalling the course record *(Chris Smith/Sunday Times)*

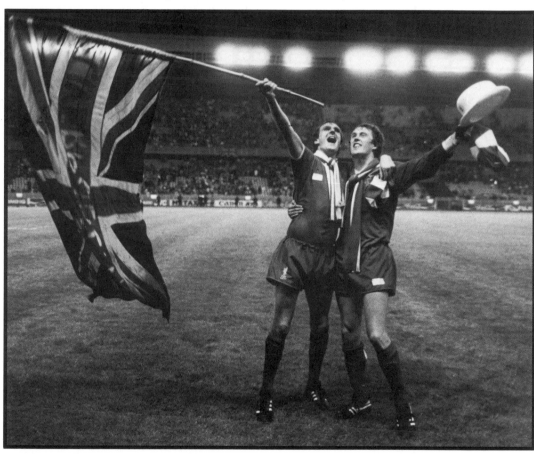

Liverpool's third European Champions' Cup win – and the fifth in succession by an English club – came with a 1–0 victory over the Cup's first winners, Real Madrid, in Paris and crowned the remarkable career of Bob Paisley with his tenth honour in less than seven years as manager. *(Eamonn McCabe/The Observer)*

1982

The sign of the shamrock was over the land, shining brightly on the copper head of a lithe leprechaun named Ollie Campbell, fly-half to an Irish rugby union side which rolled to its first Triple Crown for 33 years, climaxed by a 21-12 win over Scotland in Dublin in which 'darlin' boy Ollie' scored all his side's points, equalling a 23-year-old world record. But rugby administration still struggle to catch up with the 20th Century. The England hero of 1981, Bill Beaumont, was barred from taking any further part in the game when he decided to keep the proceeds from a book about his career after injury had forced his early retirement. Then there was the embarassment of a German shoe company revealing that it had 'put money in the boots' of players to wear their gear. England responded to that by making their players black out the logos on their boots.

Money made another mess of cricket when 15 English players accepted contracts said to be worth £25-30,000 to play an unofficial Test series as an 'England XI' in South Africa. All were banned from official Tests for three years. Fortunately for English cricket-watchers Ian Botham (and captain Bob Willis) refused the South African offers and compensated with a typical innings against India scoring 200 off only 225 balls and twice landing sixes on the Oval grandstand roof.

There was a deal of confusion in motor-racing also before Keke Rosberg became the first Finn to win the world Formula 1 championship. He did it in the Swiss Grand Prix, held in France, which officials twice miscounted the number of laps left before Rosberg finally got the chequered flag.

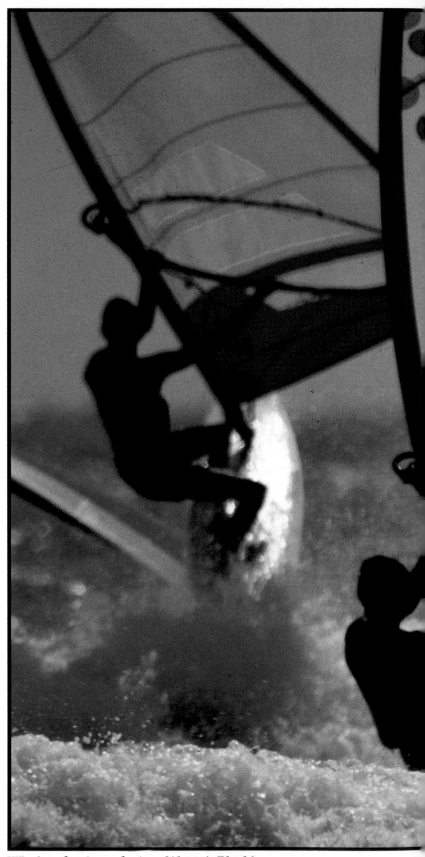

Wind surfers jump for joy (*Alastair Black*)

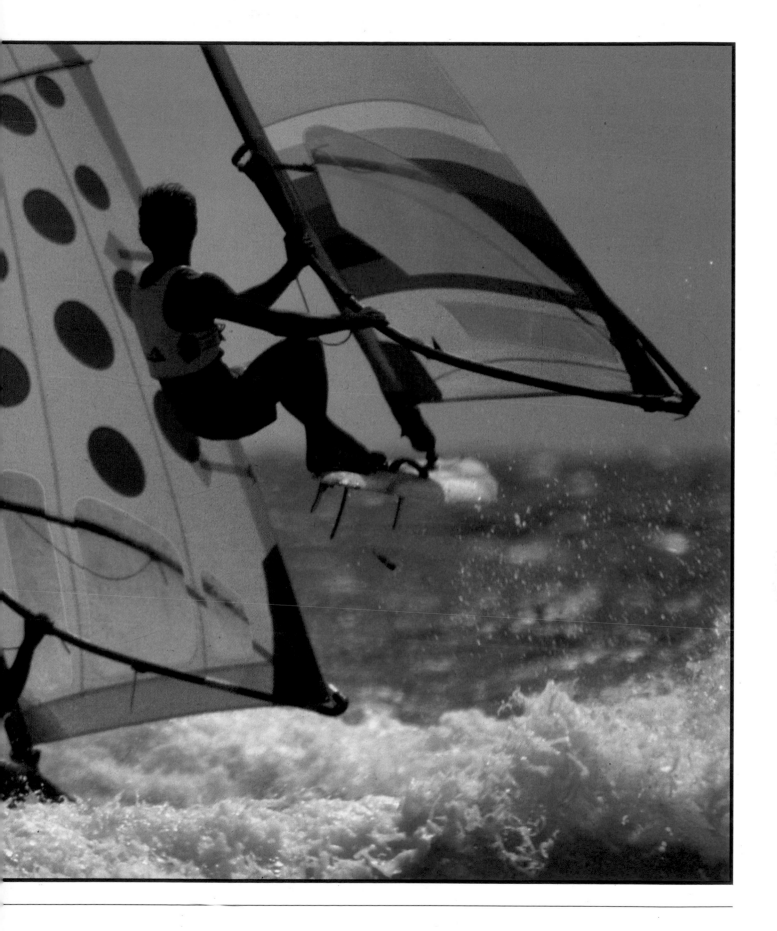

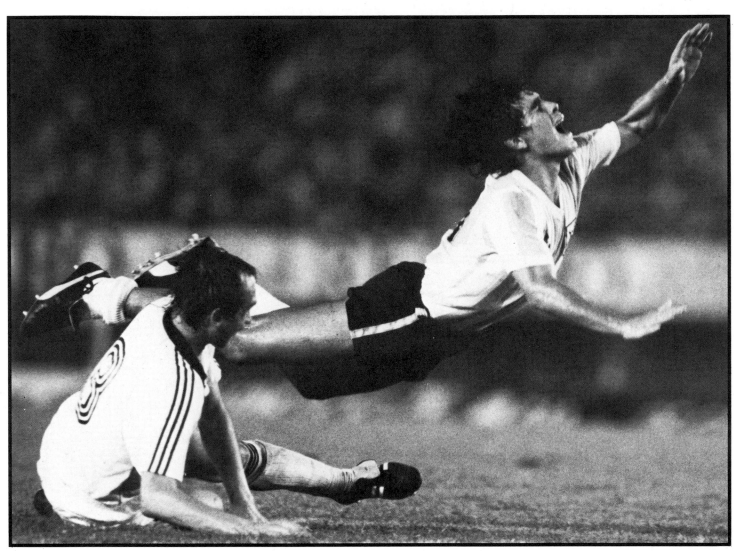

Italy won soccer's World Cup, in Spain but it was Argentinian Diego Maradona who stayed to reign in Barcelona in exchange for a cool £4.8 million. Real Madrid's West German international Ulli Stielike (left) was among those who tried to bring the world's most expensive footballer down to earth *(Eamonn McCabe/ The Observer)*

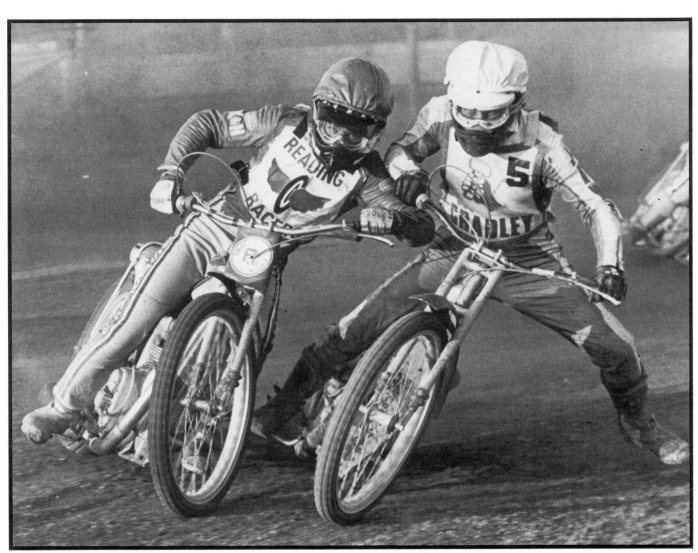

Getting the elbow (*Trevor Meeks*)

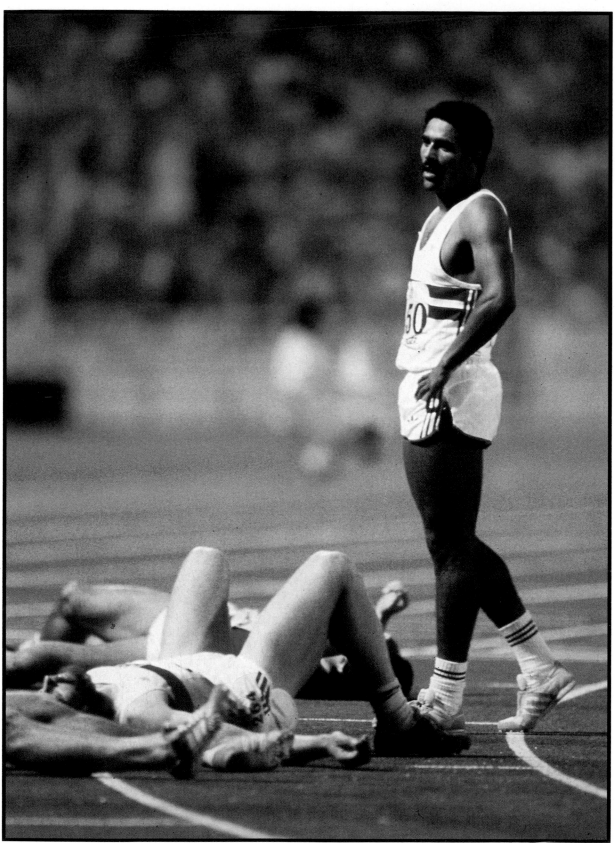

Britain's greatest athletics all-rounder Daley Thompson celebrates another world decathlon record at the Athens European championships *(Colin Elsey/Colorsport and Tony Duffy/All-Sport)*

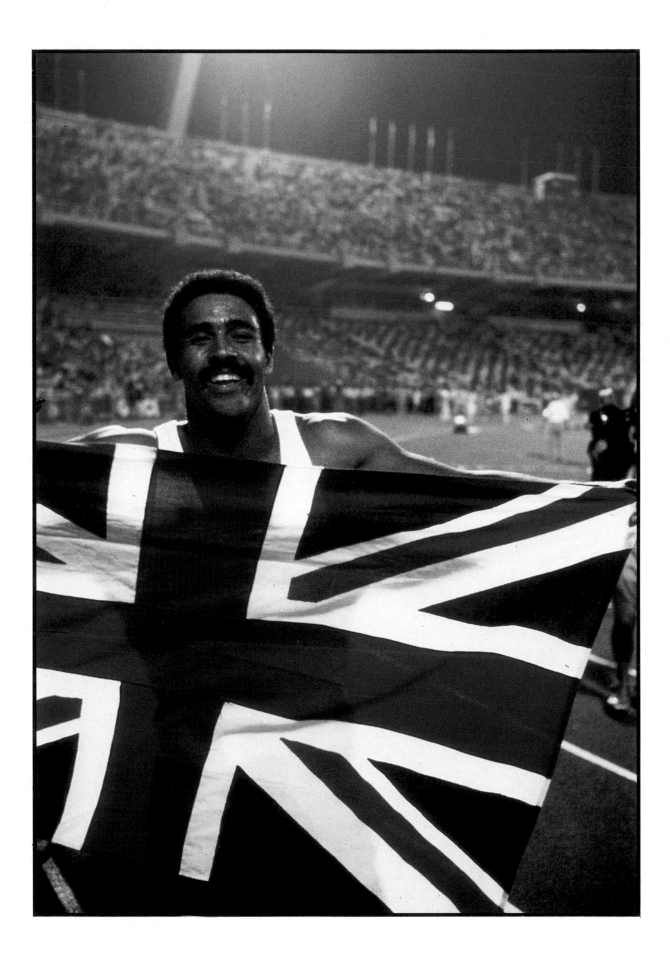

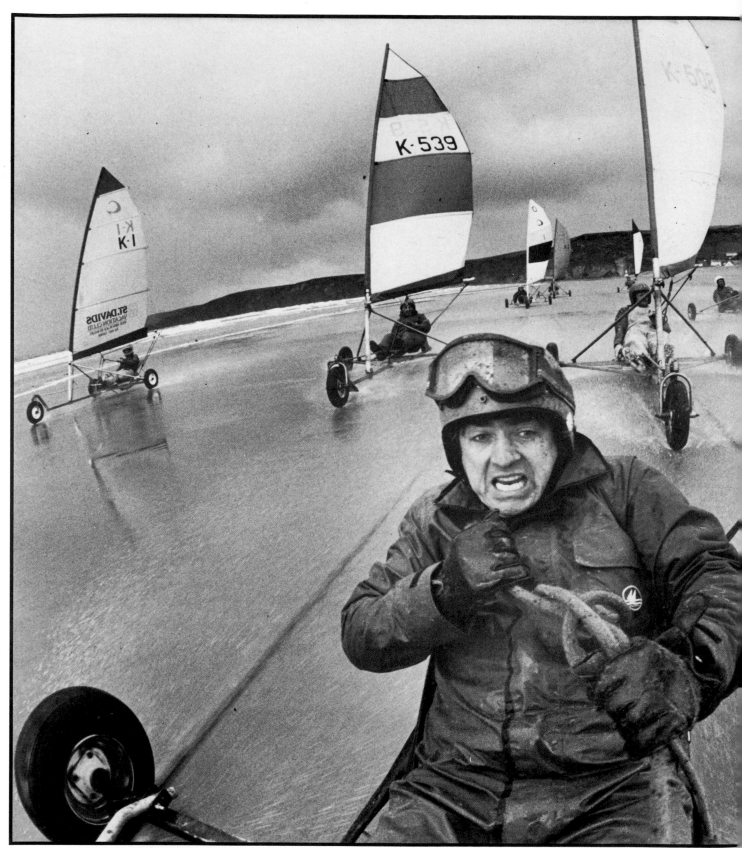

Sand yachting *(Chris Smith/Sunday Times)*

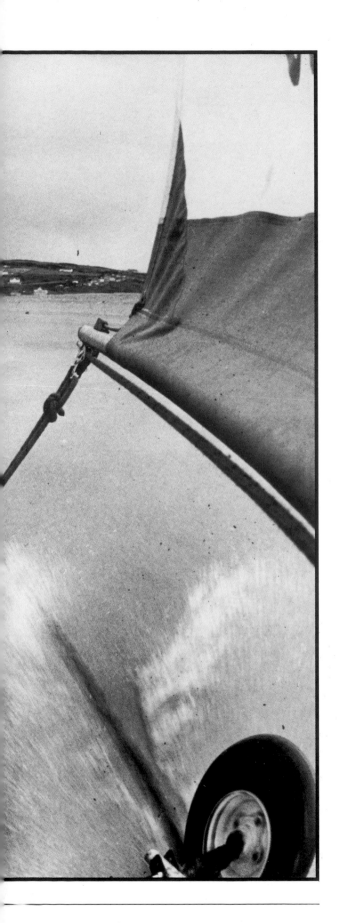

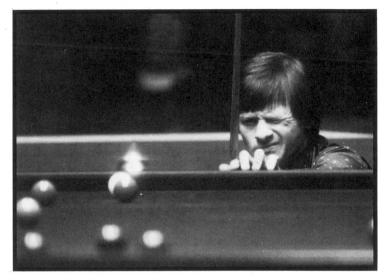

Eye of the 'Hurricane' (*John Dawes/Daily Star*)

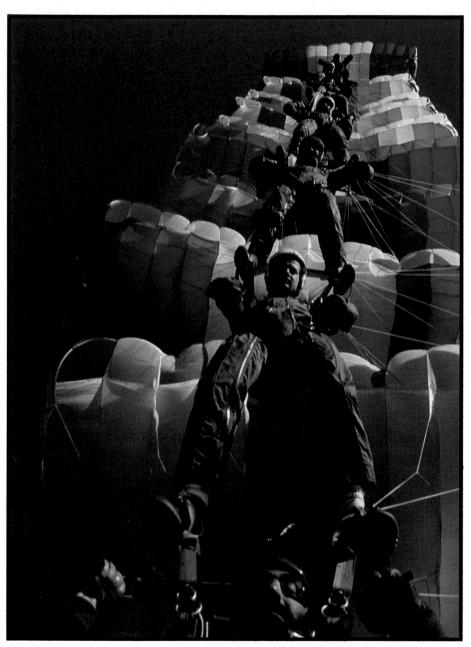

The view from a camera strapped to the photographer's foot during
the British Parascending Team's canopy – relative routine *(Dave Waterman)*

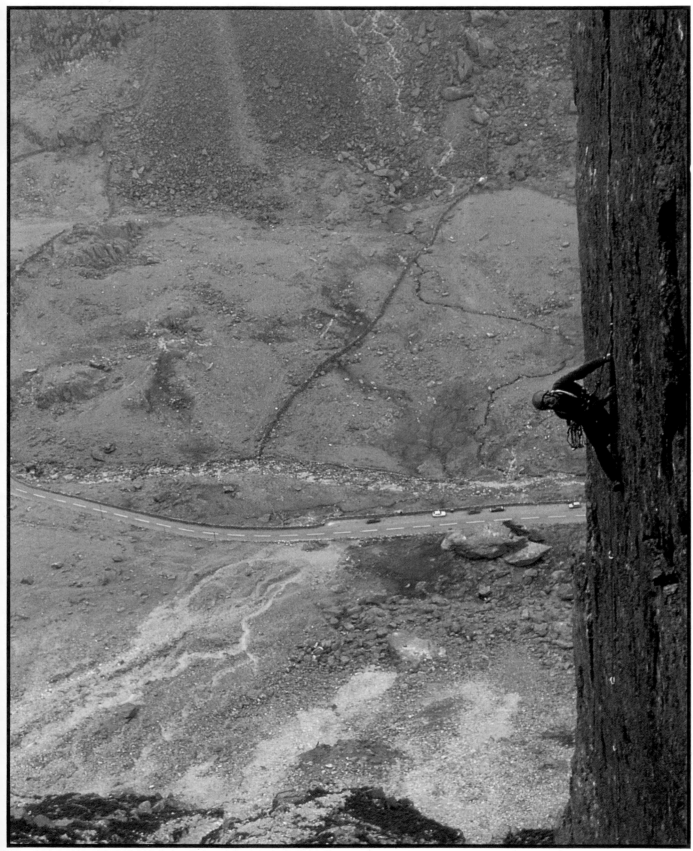

It's a long way down – and up *(Steve Powell/All-Sport)*

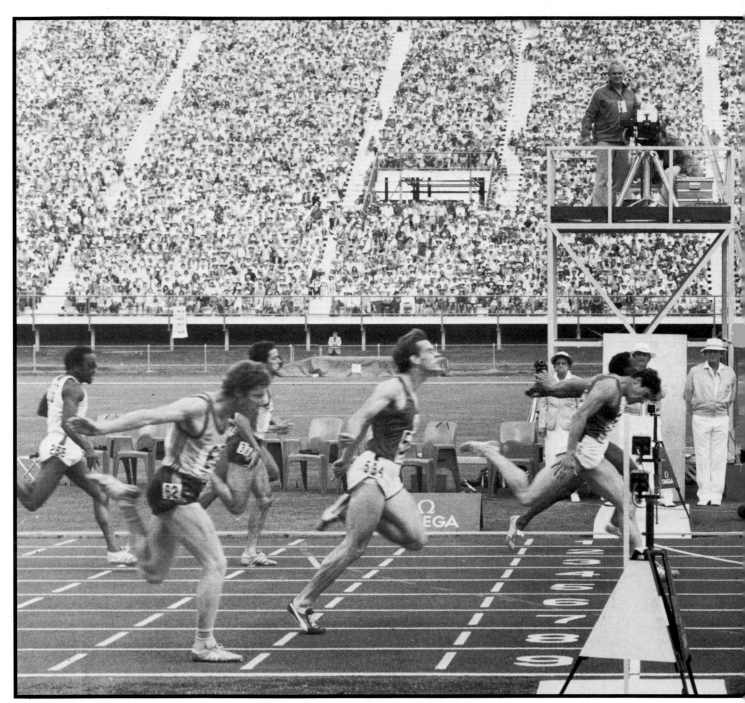

At the Commonwealth Games in Brisbane, Australia, Scotland's Allan Wells (nearest camera) and England's Mike McFarlane battled stride for stride over 200 metres and even electronic timing to one-hundreth of a second could not separate them at the finish. Both clocked 20.43 sec and both collected gold medals for a feat unprecedented in championship athletics *(Leslie Williamson)*

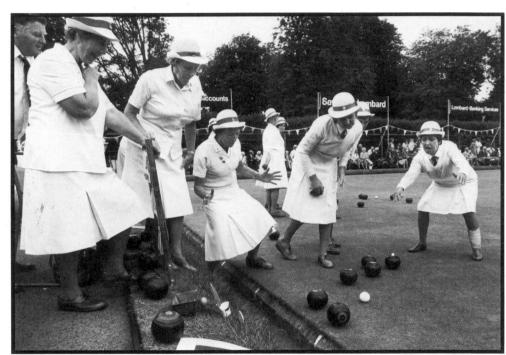

Left a bit, right a bit . . . ladies bowls *(Richard Gardner)*

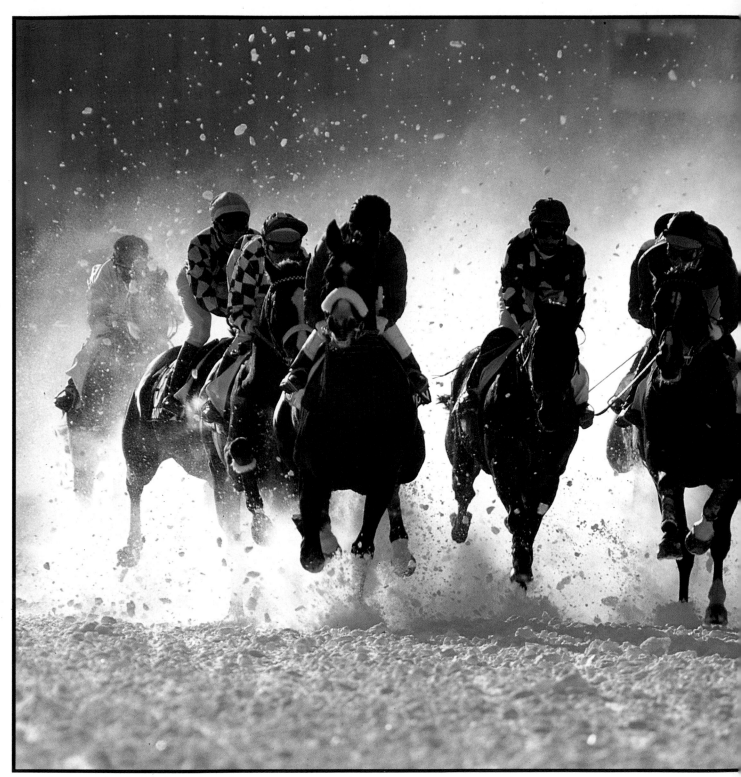

Snow horses at St. Moritz *(Leo Mason)*

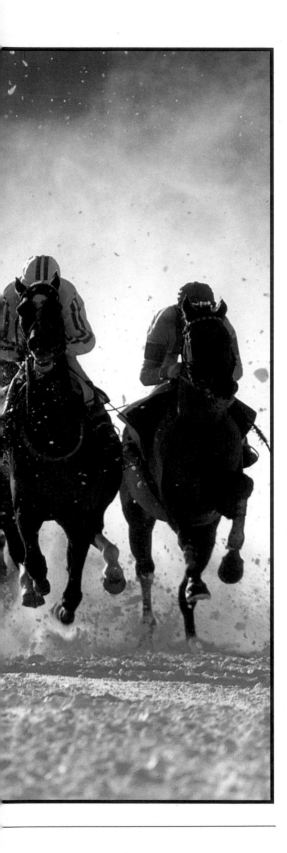

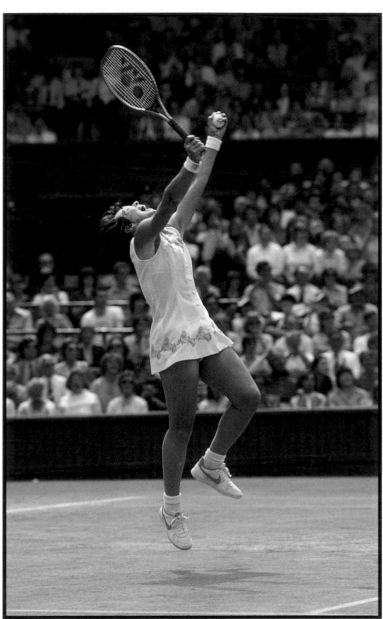

After five successive victories, Bjorn Borg gave up Wimbledon, but 38-year-old Billy Jean King who had known the place for 21 of its 60 years was happy to end a rain-lashed fortnight reaching the semi-finals for the 13th time and playing her 100th singles on the way. *(Don Morley)*

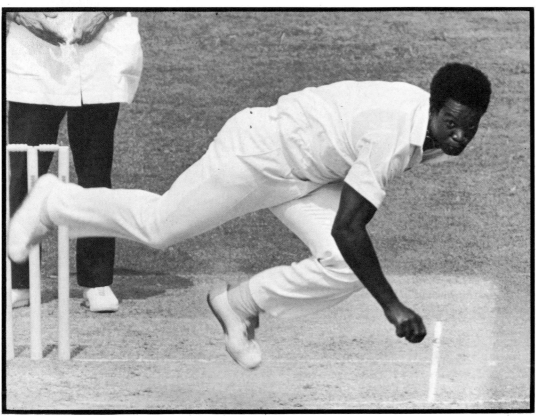

Norman Cowans follows through *(Patrick Eagar)*

Staying in touch . . . Ivan Le

1983

Five armed men provided the sports story of the year, if not the decade, when they stole £10-million worth of horseflesh named Shergar from an Irish stud farm and held it to ransom for £2 million. Deals were offered and rewards sought but neither the horse – winner of both the English and Irish Derbys – nor its abductors were ever heard of again. A racing Miss Marple would have solved the mystery successfully, for 1983 was the women's year in the sport: Mrs Jenny Pitman first to handle a Grand National winner; Caroline Biche, first jockey to win at Cheltenham; Mrs Mercy Rimell, first to saddle a Champion Hurdle winner; Criquette Head first to train an English Classic winner in the 1,000 Guineas. In Sweden, a 20-year-old

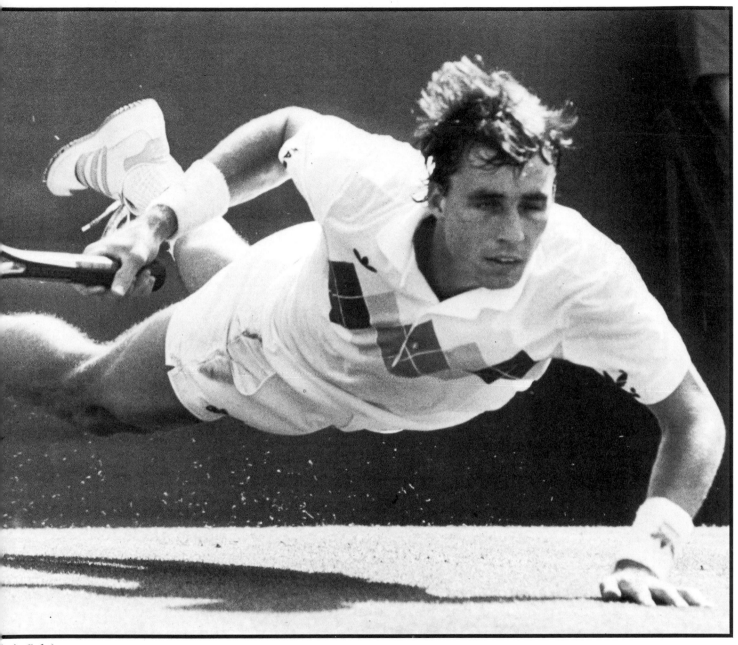

(*ris Cole*)

named Sofia Mordgren even became the first woman champion jockey.

But none of them could have provided the cash to rescue Shergar as handily as the Queen of the tennis courts, Martina Navratilova, who brought her career earnings to over £4 million with victories in the Wimbledon and US Opens (the latter at £1,131 a minute on court). She outstripped not only the men in her own sport but also those in the most lucrative, golf, where Severiano Ballesteros, winner of the US Masters for the second time in four years, managed only 300,000 dollars as his top prize.

But one of the most astonishing victories of the year came in the third cricket World Cup, won by India who beat the holders West Indies in the final after having won only one match in the previous tournaments.

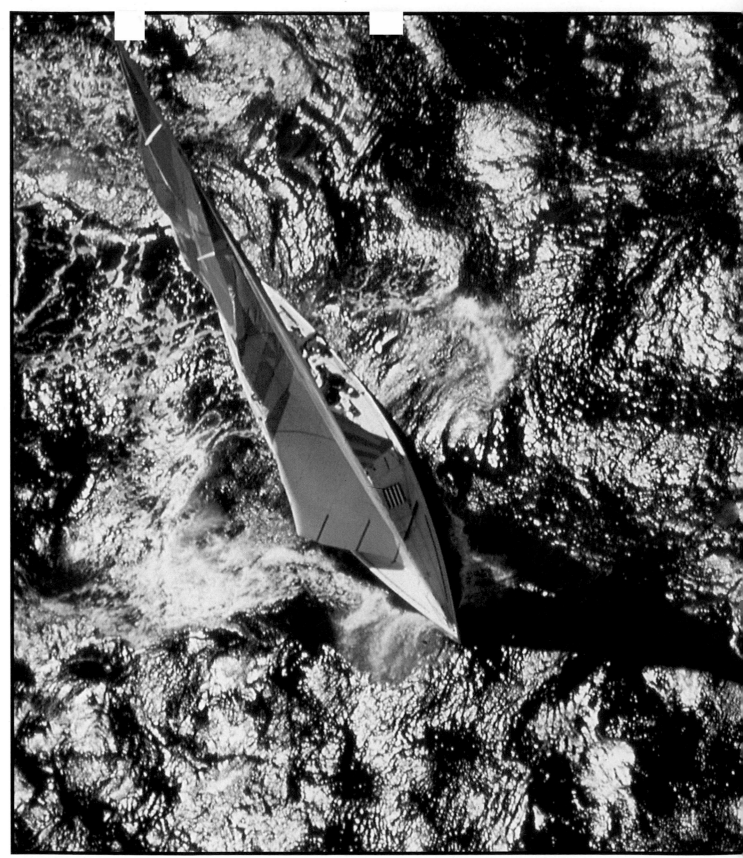

It took 132 years and 25 attempts to prise yachting's America's Cup from the New York Yacht Club, but *Australia II* did it in sty

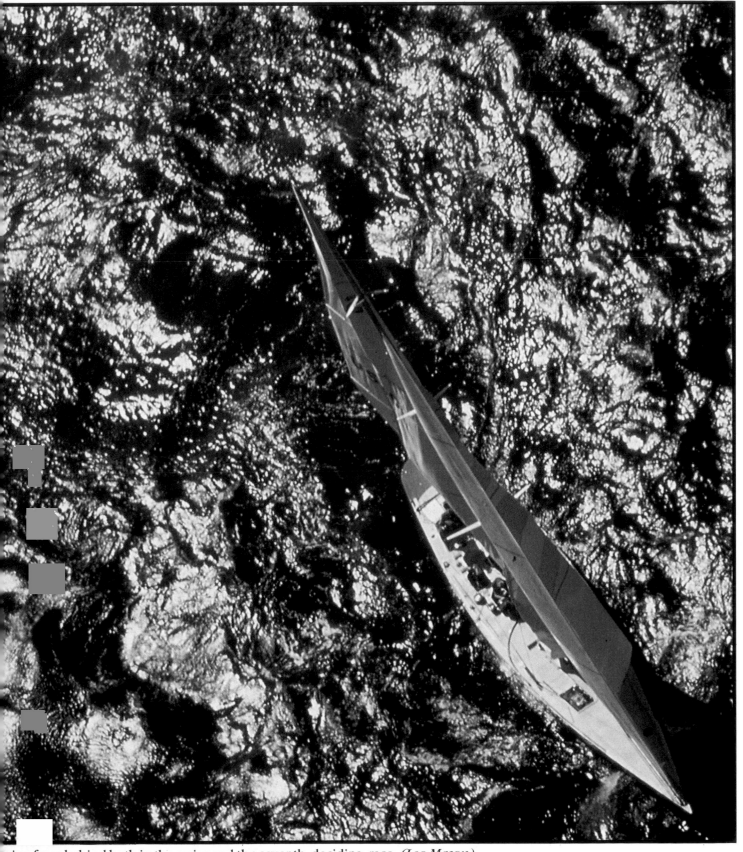

ning from behind both in the series and the seventh, deciding, race. *(Leo Mason)*

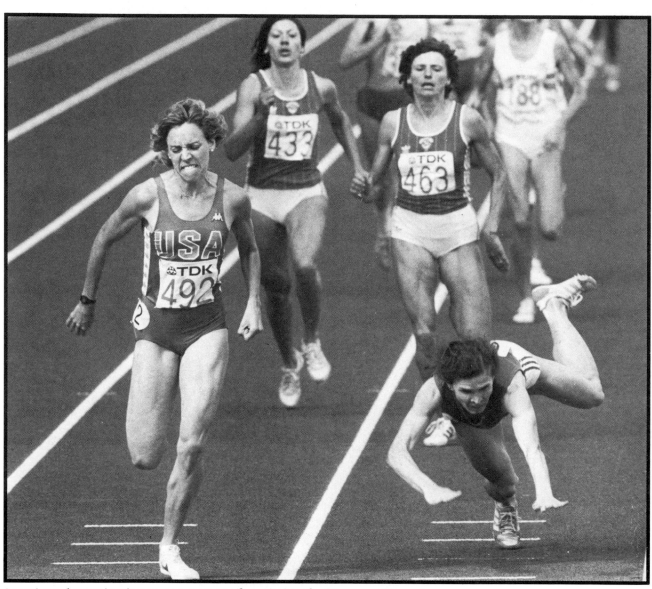

American determination to compensate for missing the Moscow Olympics typified by Mary Decker, who upset Eastern European women's domination in the 1,500 and 3,000 metres to win both titles at the first official athletics world championships in Helsinki *(Hugh Routledge)*

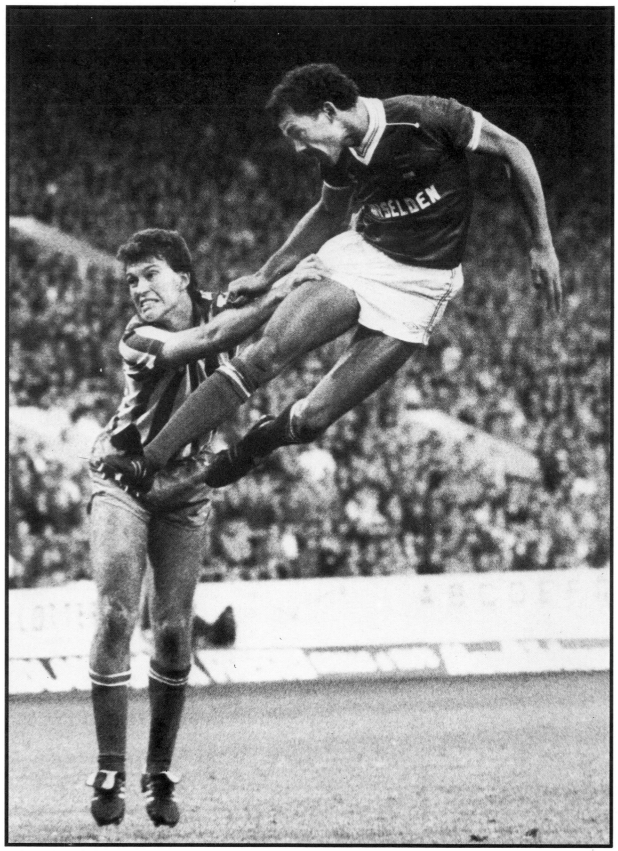

Helping hand *(Steve Hale)*

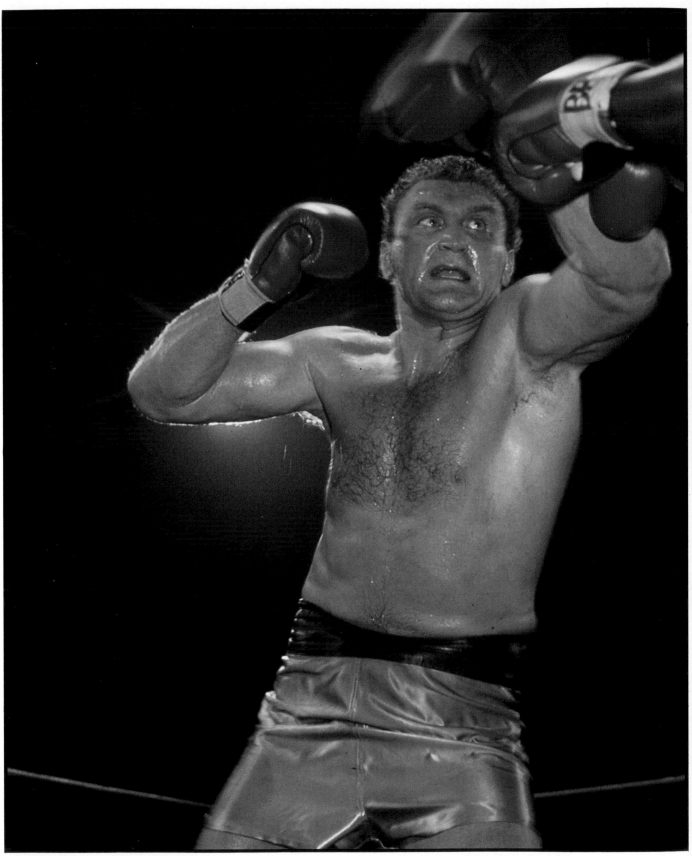

Joe Bugner, once holder of three heavyweight titles and a contender for the world crown *(Bob Thomas)*

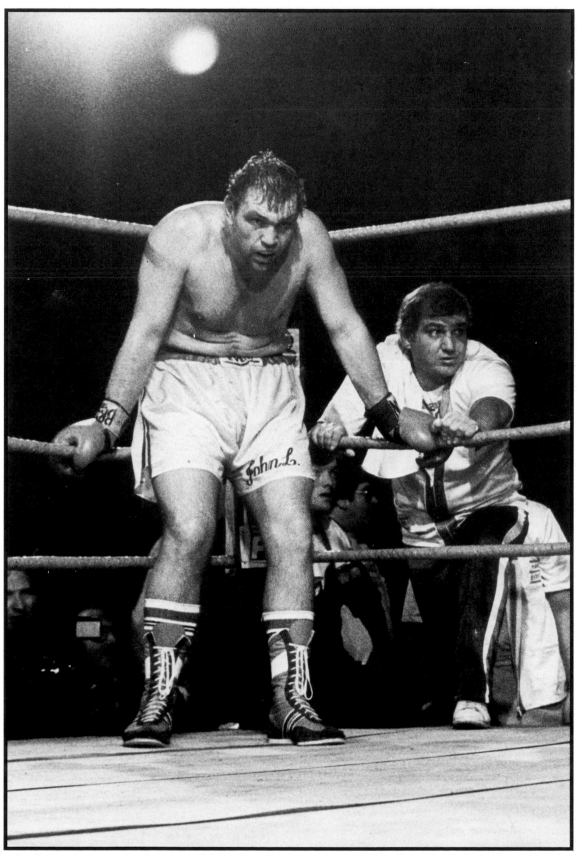

John L. Gardner sought the same titles as Bugner but retired earlier *(David Ashdown/Daily Star)*

1984

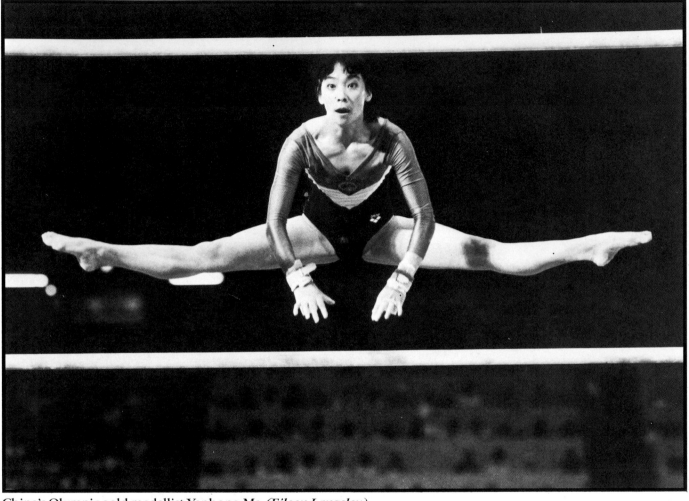

China's Olympic gold medallist Yanhong Ma *(Eileen Langsley)*

The Soviet Union, duly followed by all its Eastern European acolytes except Rumania, obtained its 'revenge' for 1980 by boycotting the Los Angeles Olympics and there was more than a suspicion that the ulterior motive was because the red-shirted Soviets more than suspected that in front of their own jingoistic crowds for the first time in 52 years, the Americans were going to prove pretty nearly invincible in whichever branch of Citius, Altius, Fortius anyone else chose to take them on. And so it proved.

For Britain, the highlight was the triumph of Sebastian Coe in becoming the first to win the Olympic 1,500 metres in successive Games.

The English needed a little glory to spread throughout the land after one of the most disastrous cricket seasons on record. Beaten, nay humiliated by West Indies 5-0 at home for the first time, blown out by the hurricane bowling of Garner, Marshall and Holding and blasted by the bats of Greenidge, Richards, Gomes and Lloyd, England were so demoralised that it was all they could do to hold Sri Lanka to a draw in their first eve Test at Lords.

But there was some cheer on the racecourses at Sandown, where the Queen Mother won the Whitbread Gold Cup; at Epsom where young trainer David O'Brien bea his dad, Vincent into second place in the Derby; and at Doncaster where Lester Piggott wo his record 28th Classic victory in the St Leger.

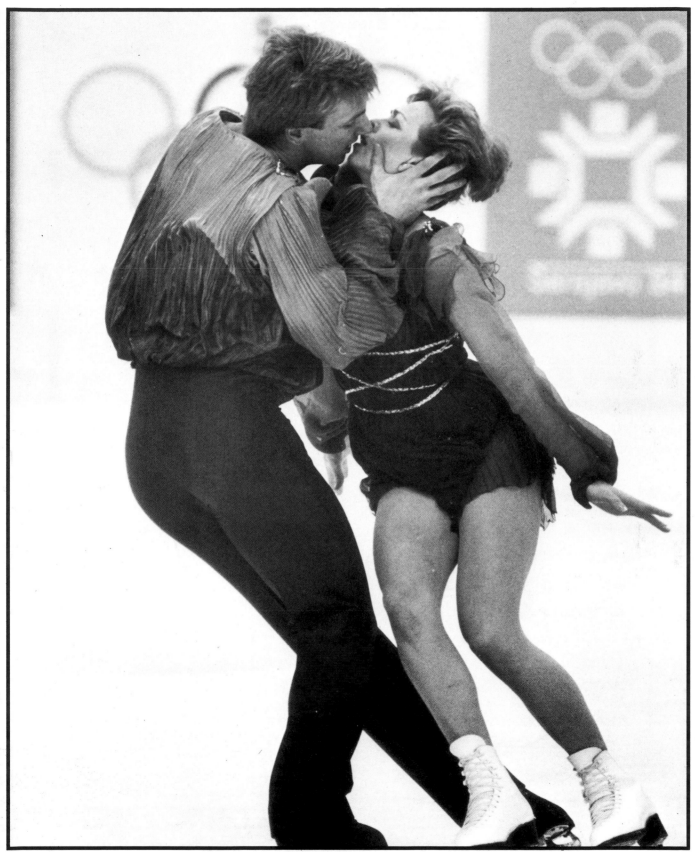

Perfection from Jayne Torvill and Christopher Dean, world, Olympic and European
ice-dance champions *(David Caulkin/Associated Press)*

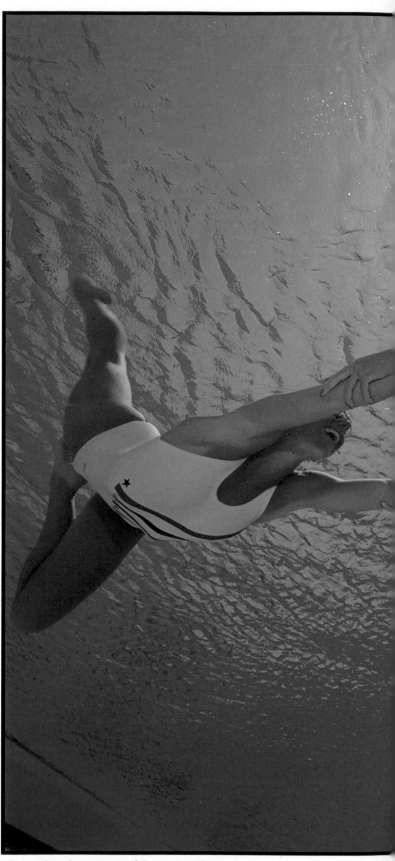

The stylised routines of the new Olympic event, synchronised swi

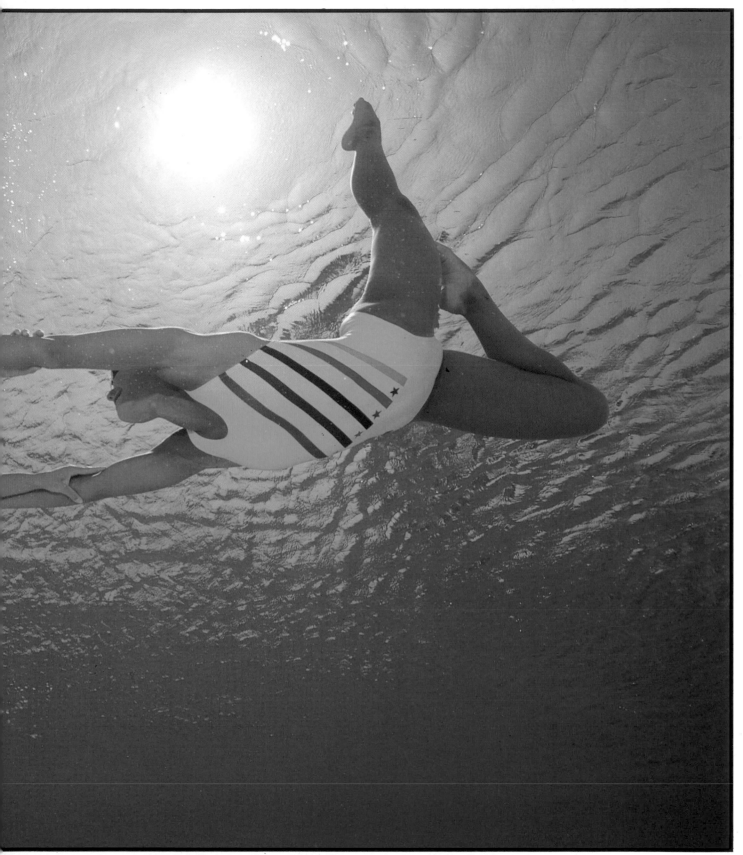

g shown by American gold-medallists Candy Costei and Tracy Ruiz *(Steve Powell/All-Sport)*

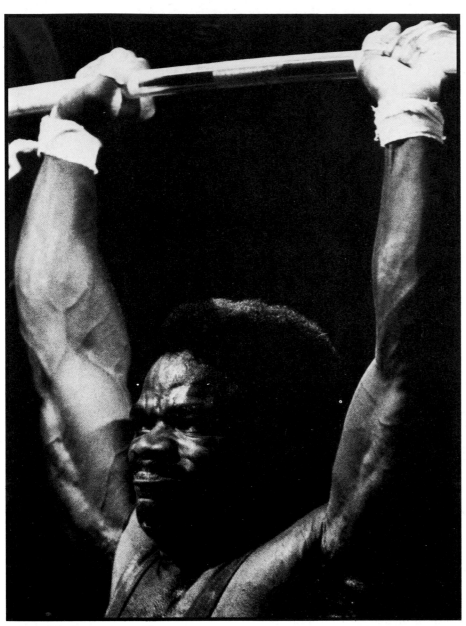

Power lift *(Steve Yarnell)*

Scottish International water skier

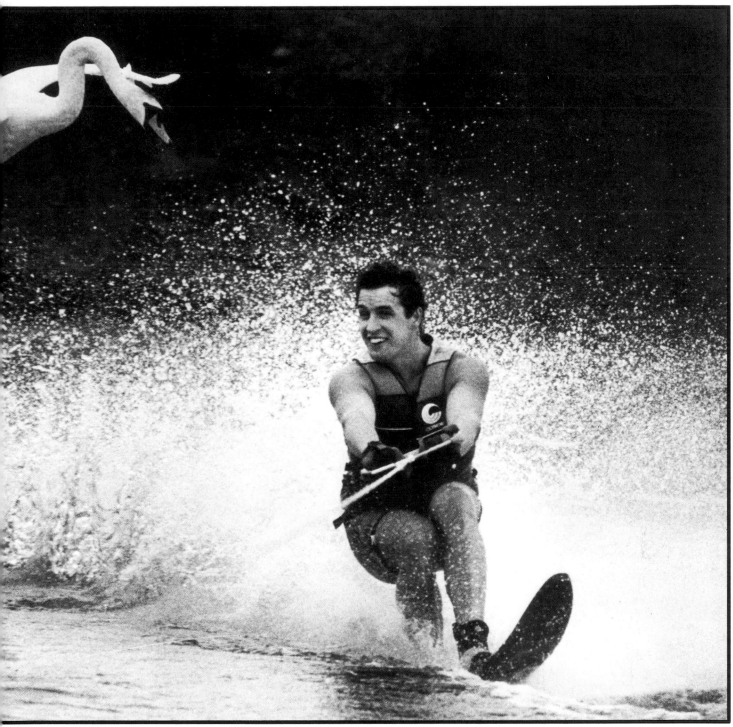
ob finds practising can be perilous *(Ken Ferguson/Daily Record)*

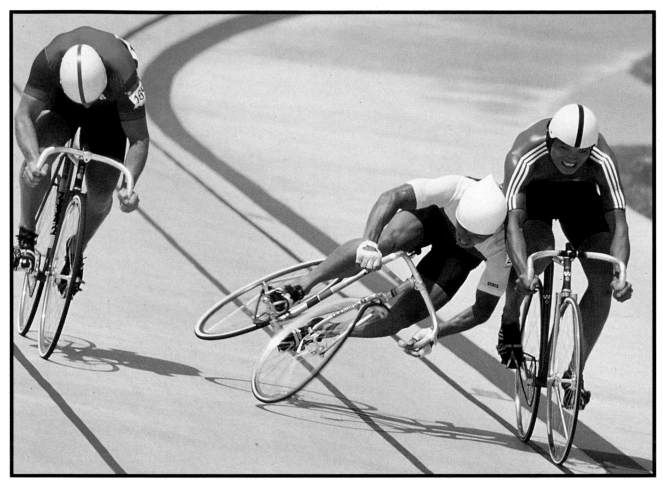

Cycling chaos in the Olympic velodrome *(David Cannon/All-Sport)*

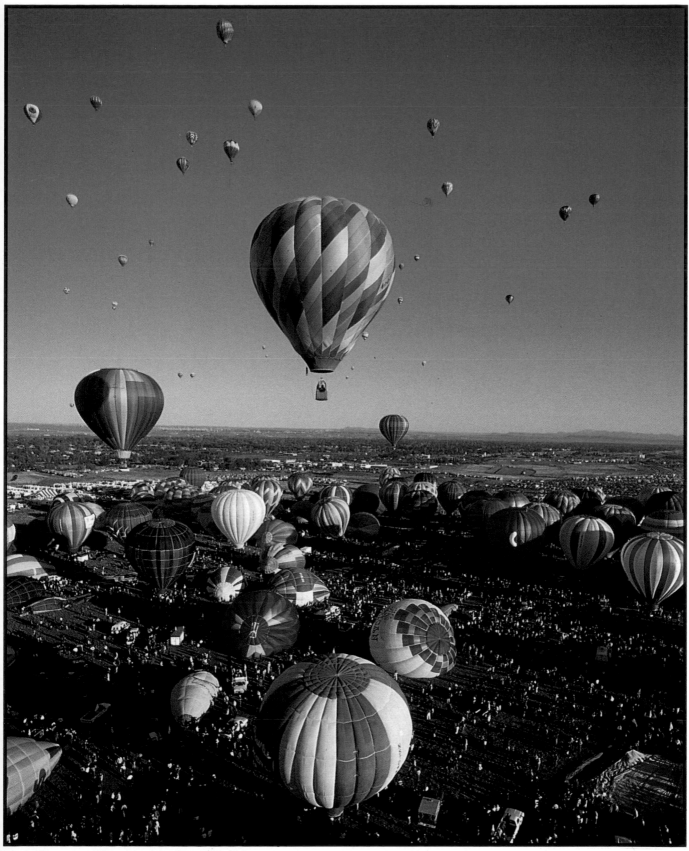

Big balloons at Albuquerque *(Leo Mason)*

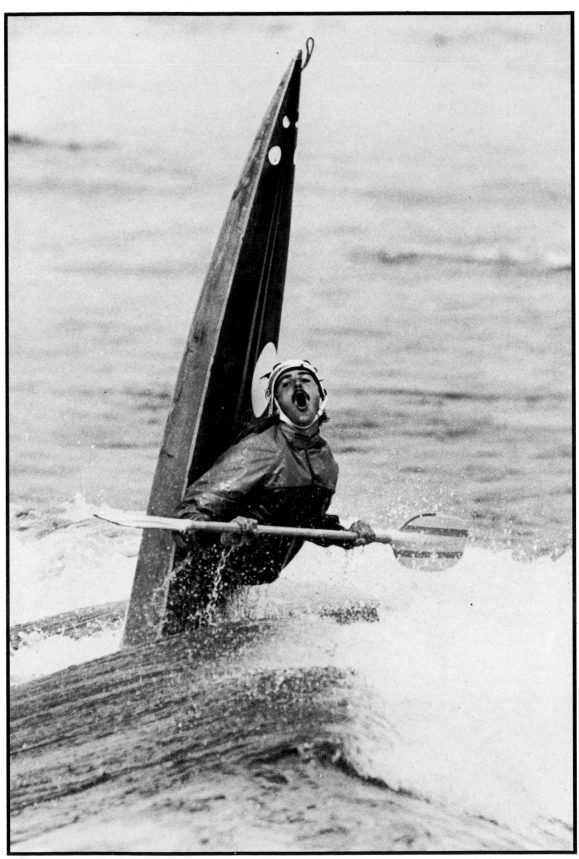

Going over . . . *(Ian Hossack/Glasgow Herald)*

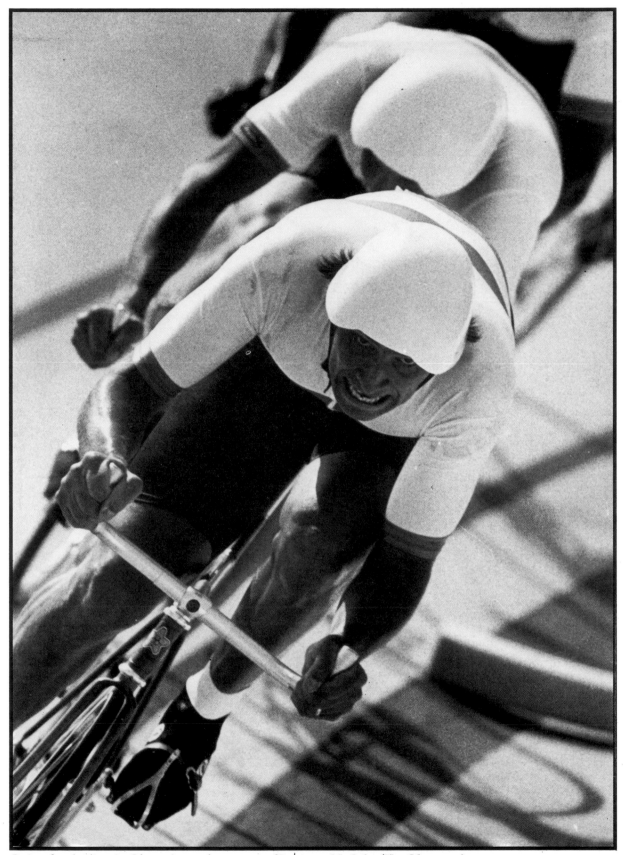

Going for the line in Olympic tandem event *(Eamonn McCabe/The Observer)*

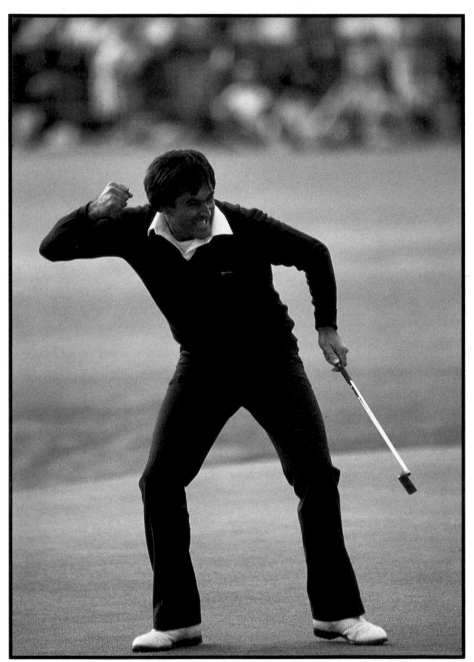

Severiano Ballesteros, a jubilant winner of the British Open for the second time *(Phil Sheldon)*

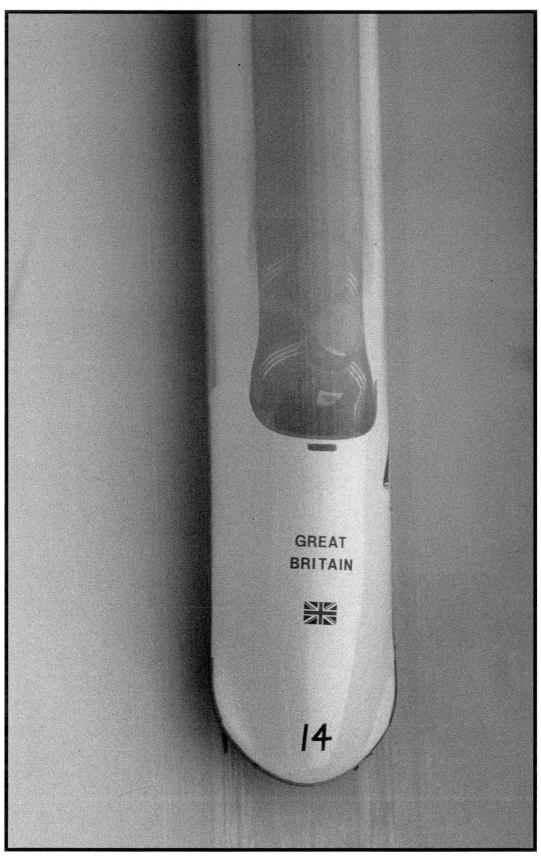

GREAT
BRITAIN

14

Britain's 4-man Olympic bobsleigh team *(Leo Mason)*

SPORT FOR ALL

Sport for All is the Sports Council's national drive to encourage and help people to take up a sporting activity and to increase the opportunities available to play sport. The aim is to get another 1.7 million more men and 3.9 million more women playing sport in the next ten years. The Sport for All award goes to the photographer whose picture best conveys this theme and it is a category which has highlighted some off-beat sporting moments.

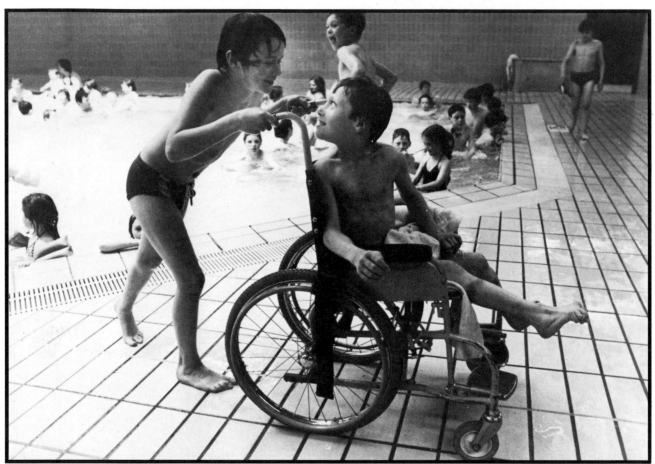

Sport is for all *(Ian Torrance, Daily Record)*

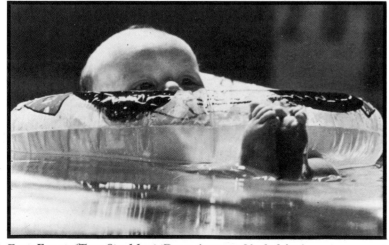

Eyes Front *(Tom Stoddart, Press Agency, Yorkshire)*

Swimming at Swiss Cottage *(Tommy Hindley)*

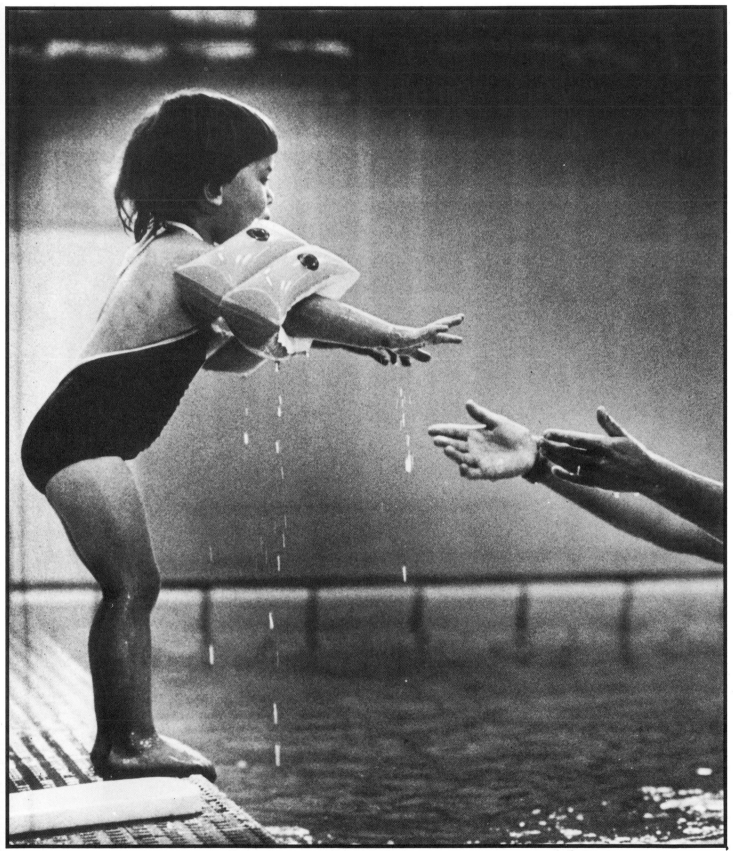

Helping hand . . . *(Bradley Ormesher, Harry Ormesher Photography)*

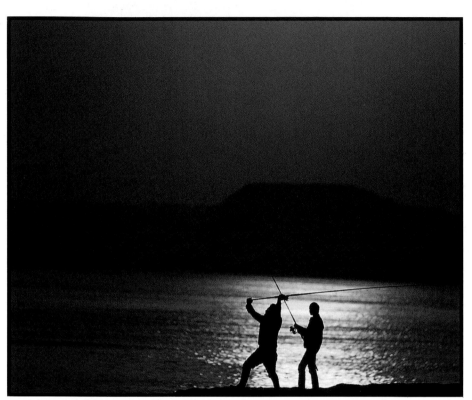

Fishing from the beach at Abbotsbury *(David Wills)*

Not Peter Shilton . . ! *(Ray Green)*

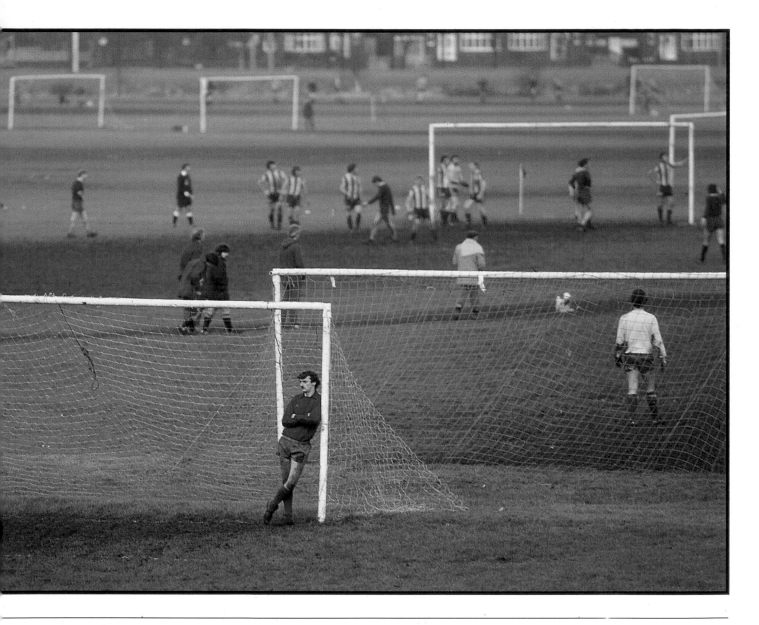

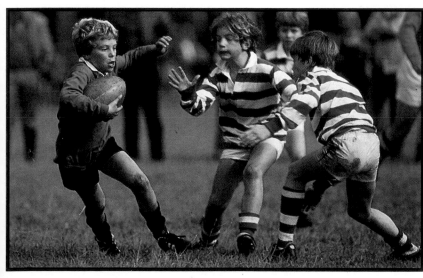

Mini rugby *(Eileen Langsley)*

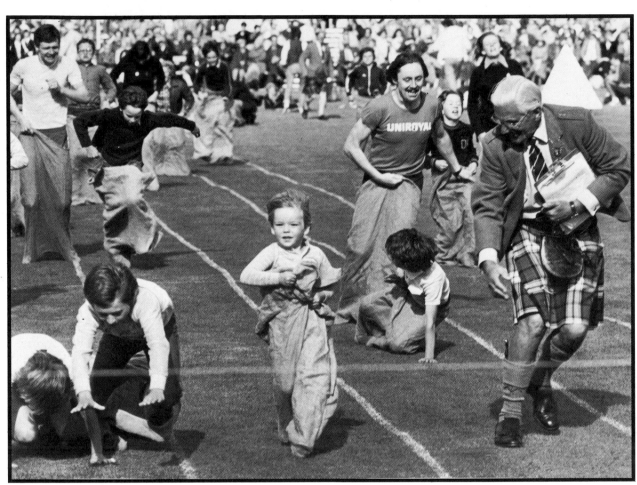

Jump to it! *(Howard Walker/Sunday Mirror)*

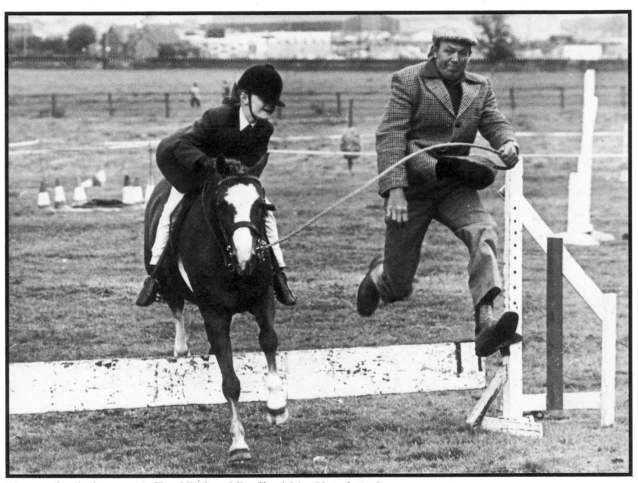

'You can lead a horse . . .' *(Paul Pickard/Staffordshire Newsletter)*

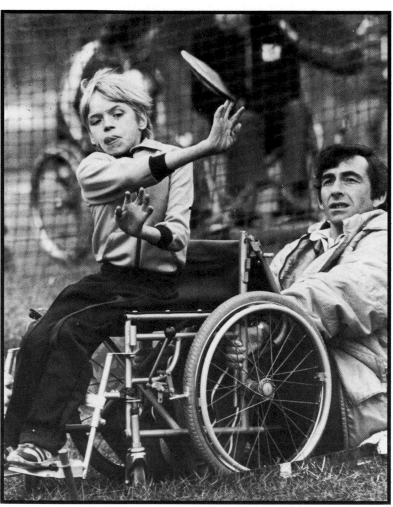

Steady as she goes! *(David Rice-Evans)*

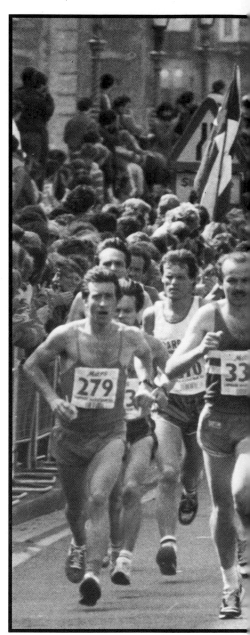

It's all about taking part . . . *(Tony Sapiano*

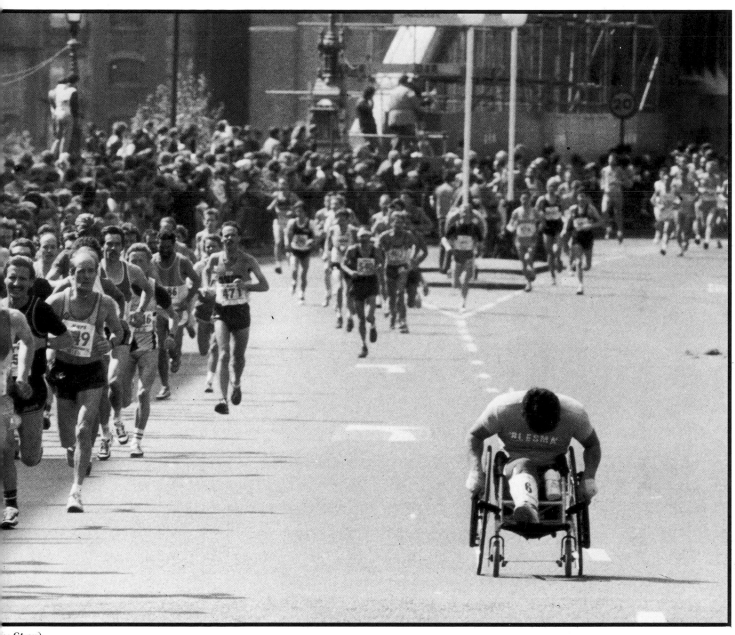

THE SPORTS PHOTOGRAPHER OF THE YEAR

(Freelance unless otherwise stated)

1975
Winner
Tony Duffy (All-Sport)
Highly Commended
Patrick Eagar
Don Morley
Alastair Black
Sports Picture Winner
Mike Roberts (Army PR)
Highly Commended
Alec Russell
Leo Mason
Stewart Fraser (Colorsport)
Sport For All Winner
Ray Green
Highly Commended
Ray Green

1976
Winner
Chris Smith (The Observer Magazine)
Highly Commended
Gerry Cranham
Sports Picture Winner
Clive Limpkin (Daily Mail)
Runner-up
Harry Ormesher (Sunday People)
Highly Commended
Reg Lancaster (Daily Express)
Peter Jay (The Sun)
John Varley
Sport For All Winner
Gerald Armes (Birmingham Evening Mail)
Highly Commended
Stanley Machett (The Mirror)
Roger Grayson (Mansfield Chronicle Advertiser)

1977
Winner
Gerry Cranham
Colour Portfolio Winner
Gerry Cranham
Highly Commended
Tony Duffy (All-Sport)
Leo Mason
Black and White Portfolio Winner
Eric Piper (The Mirror)
Highly Commended
Patrick Eagar
Adrian Murrell
Sports Picture Winner
Eric Piper (The Mirror)
Highly Commended
Alfred Markey (The Mirror)
Colin Elsey (Colorsport)
Keith Randall
Sport For All Winner
Tony Duffy (All-Sport)
Highly Commended
Tom Stoddart (Press Agency (Yorkshire) Ltd)

1978
Winner
Eamonn McCabe (The Observer)
Colour Portfolio Winner
Alastair Black
Highly Commended
Tony Duffy
Leo Mason
Black and White Portfolio Winner
Eamonn McCabe (The Observer)
Highly Commended
Bob Thomas
Patrick Eagar
Mervyn Rees
Sports Picture Winner
Eamonn McCabe (The Observer)
Highly Commended
Albert Foster (The Mirror)
Brendan Monks (Sunday People)
Mike Roberts
Sport For All Winner
Don Morley
Highly Commended
Jeffrey Heath (Birmingham Mail)

1979
Winner
Eamonn McCabe (The Observer)
Colour Portfolio Winner
Leo Mason
Highly Commended
Tony Duffy (All-Sport)
Steve Powell (All-Sport)
Black and White Portfolio Winner
Eamonn McCabe (The Observer)
Highly Commended
Tommy Hindley
Sports Picture Winner
Eamonn McCabe (The Observer)
Highly Commended
Stuart Paterson (Glasgow Herald)
Tommy Hindley
Sport For All Winner
Tommy Hindley
Highly Commended
Ray Green
Ian Bradshaw (Glasgow Herald)

1980
Winner
Chris Smith (Sunday Times)
Colour Portfolio Winner
Guy Gurney
Highly Commended
Dave Waterman
Black and White Portfolio Winner
Chris Smith (Sunday Times)
Highly Commended
John Dawes (The Star)
Sports Picture Winner
Chris Smith (Sunday Times)
Highly Commended
Bob Thomas (Bob Thomas Sports Photography)
Sport For All Winner
Ian Hossack (Glasgow Herald)
Highly Commended
Paul Pickard (Staffordshire Newsletter)

1981
Winner
Eamonn McCabe (The Observer)
Colour Portfolio Winner
Phil Sheldon
Highly Commended
Leo Mason
Guy Gurney
Black and White Portfolio Winner
Eamonn McCabe (The Observer)
Highly Commended
Chris Smith (Sunday Times)
Ian Stewart (Sunday Standard, Glasgow)
Sports Picture Winner
Mike Brett
Highly Commended
Phil Sheldon
Steve Yarnell
Sport For All Winner
Howard Walker (Sunday Mirror)
Special Disabled Category
David Rice-Evans

1982
Winner
Chris Smith (Sunday Times)
Colour Portfolio Winner
Alastair Black
Highly Commended
Leo Mason
Mark Leech
Black and White Portfolio Winner
Chris Smith (Sunday Times)
Highly Commended
Steve Yarnell
John Dawes (The Star)
Sports Picture Winner
Alastair Black
Highly Commended
Eamonn McCabe (The Observer)
Roy Peters
Sport For All Winner
Steve Hale
Highly Commended
Ray Green
Ian Torrance (Daily Record)

1983
Winner
Bob Thomas (Bob Thomas Sports Photography)
Colour Portfolio Winner
Bob Thomas (Bob Thomas Sports Photography)
Highly Commended
Tommy Hindley
Michael King (Bob Thomas Sports Photography)
Black and White Portfolio Winner
Bradley Ormesher (Harry Ormesher Photography)
Highly Commended
Patrick Eagar
Tommy Hindley
Sports Picture Winner
Chris Cole
Highly Commended
John Burles
Dave Ashdown (The Star)
Sport For All Winner
Phil Sheldon

1984
Winner
Eamonn McCabe (The Observer)
Colour Portfolio Winner
Leo Mason
Highly Commended
Michael King (Bob Thomas Sports Photography)
Steve Powell (All-Sport)
Black and White Portfolio Winner
Eamonn McCabe (The Observer)
Highly Commended
Chris Cole
Chris Smith (Sunday Times)
Sports Picture Winner
Dave Caulkin (Associated Press)
Highly Commended
Kenneth Ferguson (Daily Record)
Eamonn McCabe (The Observer)
Michael King (Bob Thomas Sports Photography)
Sport For All Winner
Tony Sapiano (The Star)
Highly Commended
Craig Halkett (Evening Times, Glasgow)
Kenneth Ferguson (Daily Record)